YORK
PUBS

NATHEN AMIN

hope you enjoy the book

AMBERLEY

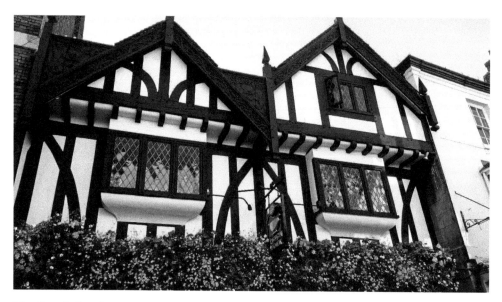

The Punch Bowl.

For my wife, Katherine.

First published 2016

Amberley Publishing
The Hill, Stroud
Gloucestershire, GL5 4EP

www.amberley-books.com

Copyright © Nathen Amin, 2016

The right of Nathen Amin to be identified as
the Author of this work has been asserted in
accordance with the Copyrights, Designs and
Patents Act 1988.

ISBN 978 1 4456 4470 7 (print)
ISBN 978 1 4456 4476 9 (ebook)

British Library Cataloguing in Publication Data.
A catalogue record for this book is available from
the British Library.

Typesetting by Amberley Publishing.
Printed in the UK.

Contents

4 HOLE IN THE WALL
5 YORK ARMS
6 GUY FAWKES INN
7 THOMAS' OF YORK
8 YE OLDE STARRE INNE
9 PUNCH BOWL
10 OLD WHITE SWAN
11 SNICKLEWAY INN
12 CROSS KEYS
13 GOLDEN SLIPPER
14 ROYAL OAK
15 GOLDEN LION
16 ROMAN BATH
17 THREE CRANES
18 BURNS HOTEL
19 KINGS ARMS
20 BLUE BOAR
21 THREE TUNS
22 GOLDEN FLEECE
23 BLUE BELL
24 BLACK SWAN
25 BAY HORSE
26 WINDMILL INN
27 PRIORY
28 FALCON TAP
29 ACKHORNE
30 MALTINGS
31 GOLDEN BALL
32 SWAN
33 RED LION
34 WATERGATE INN
35 PHOENIX
36 MASONS ARMS
37 ROOK AND CROWN
38 ROSE AND CROWN
39 WAGGON AND HORSES

Introduction

A General History of the Pub

The pub is a great British institution and has been a curiously consistent social hub for many generations of Britons. Taxation, war and economic strife has failed to consign the British public house to the past, the ubiquitous tavern enduring as a reassuring feature in the streets of villages, towns and cities throughout the land.

The introduction of the pub in Britain can be partly traced to the Roman *tabernae*, dedicated roadside outlets that served wine to passing troops. Ale had hitherto been a domestically brewed beverage among the native tribes of Britain and generally consumed within the home. The Romans acknowledged the preference of ale among the people of their new dominion and endeavoured to meet this demand through their *tabernae*, a term that provides the origin of the English name tavern.

These taverns evolved and adapted to the changing political and economic climate of the land and came to provide refuge for travellers, pilgrims and locals. Food, drink and accommodation could be found at these hospitable venues and by the medieval period were an integral part of society. An early reference to taverns can be found in a canon possibly issued by Ecgbert, Archbishop of York, in the eighth century, where it was ordained that 'no priest go to eat or drink in taverns'. The earliest known reference to an alehouse occurred in 997 in a code of law issued by King Ethelred regarding steady outbreaks of trouble occurring within these establishments. The edict stipulated 'In the case of a breach of the peace in an ale-house, 6 half-marks shall be paid in compensation if a man is slain.' Such a law hints at alehouses attaining a reputation for rowdiness and disorder from their inception.

In 1215 the Magna Carta attempted to establish 'standard measures of wine, ale and corn' while in 1267 the Assize of Ale and Bread sought to set the price of drink for the first time, two developments which serve to underline the growing importance of ale to people of the Middle Ages. The continued progression of the industry is further understood from a royal decree issued by King Richard II in 1393 which proclaimed 'whosoever shall brew in the town with the intention of selling it must hang out a sign', a statute which saw the advent of the cherished pub sign and with it a legal recognition of the alehouse. By 1557 it was recorded there were 17,000 alehouses in England and

Wales, a staggering number when put into the wider context of a population of merely a few million people.

The earliest extant reference to the pub industry in York can be found in the thirteenth-century Roll of Freemen. This fascinating document provides various references to publicans, with William de Castelford, Adam de Pontefract, Rogerus de Wambewell, William de Whityngton and Johannes de Appelby listed as 'taverners' in 1277. The first known record of a specific pub in York is that of the George, which was documented in a 1455 will as *Hospicium Georgii*. The Bull is mentioned a few years later when a Corporation Ordinance dated 27 April 1459 decreed that 'no aliens coming from foreign parts shall be lodged within the said city, liberties, or suburbs thereof, but only in the Inn of the Mayor and Commonalty, at the sign of the Bull in Conyng Street'. This regulation commanded that all visitors to the city not native to England were only to stay at the Bull, which stood on one of the city's main thoroughfares, Coney Street. Other references to fifteenth-century pubs include the Crowned Lion (1483), the Dragon (1484), the Boar (1485) and the Swan (1487).

The sixteenth century witnessed a growth in licensed premises, a development which naturally brought about an upsurge of legislature by authorities concerned with a parallel rise in drunken disorder. In 1550 there were nine inn-holders recorded in York; by 1596 this had substantially grown to sixty-four inn-holders along with 103 alehouse-keepers. Parliament in London attempted to control this public disorder with the Ale-Houses Act 1551, passed in order to control the 'abuses and disorders as are had and used in common ale-houses'. Justices of the Peace were empowered to 'remove, discharge and put away common selling of ale and beer in the said common ale-houses' in locations they considered such sanctions were necessary.

Following on from Parliament's attempts to somewhat regulate the industry, and to prevent continuing disorder, on 23 April 1562, 139 inn-holders and brewers were officially granted licences by the Corporation of York and the Lord Mayor to continue brewing ale. A decade later the Council of the North, which represented Queen Elizabeth in the region, demanded stricter enforcement of the alehouses, suggesting licensing had not curbed any widespread issues. A further act in 1604 attempted to clarify the usage of drinking houses to be for the 'Receit, Relief and Lodging of Wayfaring People travelling from Place to Place' and not for 'Entertainment and Harbouring of lewd and idle People to spend and consume their Time in lewd and drunken Manner.'

In 1663 it was recorded that York had licensed 263 public houses, and by 1700 it was reported that there was one drinking establishment for every thirty-nine people. This rise was partly bolstered by the abundance of new coaching inns that were opened in the pre-railway period to serve travellers from afar and their horses. This trend continued during the Victorian period.

The twentieth century proved to be a difficult period for the pubs of Britain, beleaguered on many fronts by various movements and developments which combined to somewhat limit the industry's hitherto rapid growth. Seebohm Rowntree's survey at

the beginning of the century concluded that York had one licensed establishment for every 230 people; it has been in steady decline ever since.

The Temperance Movement of the Victorian period vociferously campaigned against alcohol and by extension the public houses and taverns in which it was consumed. It was a socio-political campaign that attained a degree of success through incessant lobbying, although not to the extent of introducing prohibition, as was secured in America. By 1900 it was estimated that one in ten of the British adult population was teetotal, indicating the Temperance Movement's insistence that the working classes abstain from alcohol was not wholly in vain. In York this was further assisted by the intervention of noted philanthropist, social reformer and chocolatier Joseph Rowntree, a devout Quaker who embraced teetotalism. In a 100-year period culminating in the First World War, it was recorded that 138 public houses suffered closure in York. Whatever the cause it is clear that from the late nineteenth century onwards consumption of beer in public houses and taverns was markedly declining.

The commencement of the First World War in 1914 also impacted on the pub industry, with it deemed unseemly to be in a state of drunkenness during a period of national crisis. The politicians of the day attempted to castigate men who were considered reticent to join the war effort, a mentality exemplified by the Chancellor of the Exchequer, David Lloyd George, in February 1915 when he questioned why some workmen were not completing a full week's work in the armaments factories. Lloyd George exclaimed, 'What is the reason? Sometimes it is one thing, sometimes it is another, but let us be perfectly candid. It is mostly the lure of the drink … drink is doing more damage in the war than all the German submarines put together.' Increased taxation, shorter opening hours and the watering down of drinks caused many pubs to close, and by 1931 a Royal Commissioner declared that 'drunkenness has gone out of fashion'.

Further developments throughout the mid-to-late twentieth century would also contribute to the decline of pubs throughout Britain, including but not limited to an increased awareness of the effects of alcohol abuse on the human condition and alternative recreational activities available to families such as home entertainment systems and sports. More recently, supermarkets and their competitive pricing strategies have proved to be severely detrimental to the industry and have led to record pub closures in the first part of this century, currently estimated to be at a rate of over thirty a week.

York is often lauded for its rounded heritage, a feature of the city which attracts tourists from around the world. Many pubs have stubbornly survived modern redevelopment and economic misfortune and continue to serve locals and visitors alike, an integral part of the city's historic character. This book will catalogue the most intriguing of these pubs and give the reader a captivating insight to an alehouse-based history of York's past. After all, as Samuel Johnson once declared: 'There is nothing which has yet been contrived by man, by which so much happiness is produced as by a good tavern or inn.'

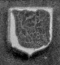

THE GEORGE INN

In Elizabethan times Ralph Rokeby Esq. (d. 1575) Secretary of the Council of the North lived in a house on this site.

Subsequently for about two and a half centuries there existed here a Hostelry known since 1614 as the George Inn, from which horsedrawn coaches departed to Hull, Manchester and Newcastle.

The sisters Charlotte and Anne Brontë stayed here in 1849.

Leak & Thorp moved to this site in 1869.

George Inn plaque.

Chapter One

The Minster Quarter

1. MINSTER INN, Marygate

The Minster Inn is situated outside the city walls on Marygate and is a charming Edwardian pub that has retained its original wood-heavy layout.

A pub in Marygate using the name Minster Inn was first mentioned in 1823 and was originally situated opposite its current location, built up against the walls of St Mary's Abbey. By 1838 it was sometimes referred to as the York Minster before officially changing its name to the Gardener's Arms in 1851 when Thomas Brown was the licensee. Brown lived in the pub with his wife Francis and children James, Anne and Frances and remained in control until 1867. William Cowling took over from the Browns and by 1872 Margaret Sotheran was landlady. By 1876 John Hopton Ward was landlord with Joseph Beck taking over in 1881.

In 1885 and 1886 the pub was known to be vacant although it had been listed as the Minster Inn in records, suggesting a name change had been implemented even without a landlord in place. In 1889 the publican was William Allison and by 1893 his son-in-law Arthur Palmer had taken over, the commencement of an almost sixty-year connection with the pub across three generations. Palmer died in 1901 aged only thirty-six and left behind his wife Harriet Ann, seven-year-old daughter Eva Ann and three-year-old daughter Minnie Beatrice.

In 1902 the Minster Inn was considered to be in a dire state and owners Tadcaster Tower Brewery resolved to construct a new pub. The brewery hired noted architect Samuel Needham and in November 1903 approval was granted to transfer the licence to a new location on the opposite side of Marygate. Harriet Ann Palmer and her daughters transferred with the pub and in 1904 she remarried, to Albert Keech. The couple continued to run the new Minster Inn and three years later she gave birth to a son named Albert Allison Keech. Harriet remained in control until her death in 1944, leaving £1,458 in her will. Her daughter Beatrice was listed as a resident of the inn when she collapsed and died in the De Grey rooms during the 1951 election results.

Needham's plan intended for a simple and efficient layout and was faithfully implemented. This original layout is still intact and remains a rare example of an Edwardian period pub unmodified during the twentieth century. The inn contains

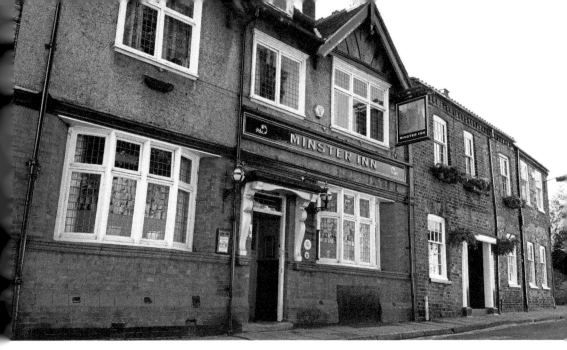

Above: Minster Inn.

Right: Front bar room, Minster Inn.

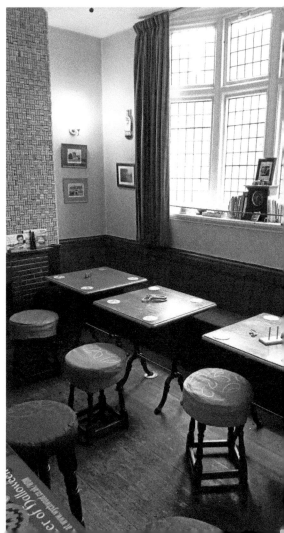

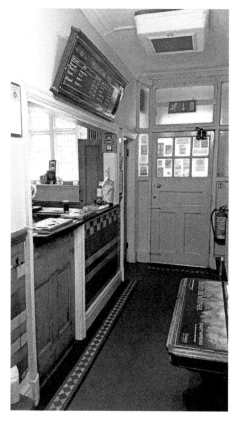

Lobby, the Minster Inn.

three equal-sized rooms with contemporary features such as bell pushes and a lobby complete with full access to the bar. Due to its interior the Minster Inn has been accredited CAMRA Heritage Pub status.

2. EXHIBITION HOTEL, Bootham

The Exhibition Hotel stands just outside the city walls on Bootham, a charming Grade II-listed pub dating from the late Victorian period. The current hotel was opened on its present spot after various redevelopments in the vicinity forced two pubs to be abandoned. The eighteenth-century Bird in Hand pub originally stood adjacent to Bootham Bar but was demolished in 1835 after the bar's barbican was pulled down. The pub was subsequently rebuilt across the road on the corner of Bootham and St Leonard's but was again forced to relocate when Exhibition Square was created in 1879. Its new permanent location was across Bootham to the site the pub presently inhabits, a building originally constructed in the late eighteenth century as a town house. The pub underwent rebranding following its relocation, taking its name from the great Yorkshire Fine Art Exhibition held that year.

Under the ownership of the Devon-born Henry Churchill the pub became known as Churchill's Hotel for a short period until it was purchased by John Smith's Brewery in 1892, who swiftly reinstated the Exhibition name. Four years later Henry Dyson,

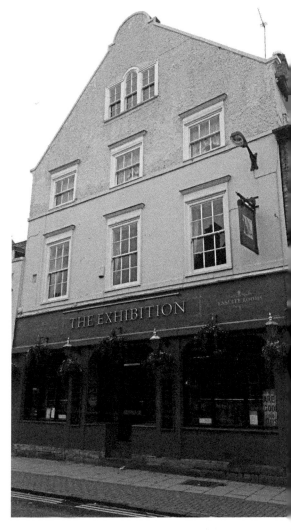

Right: The Exhibition Hotel.

Below: Victorian-style interior, Exhibition Hotel.

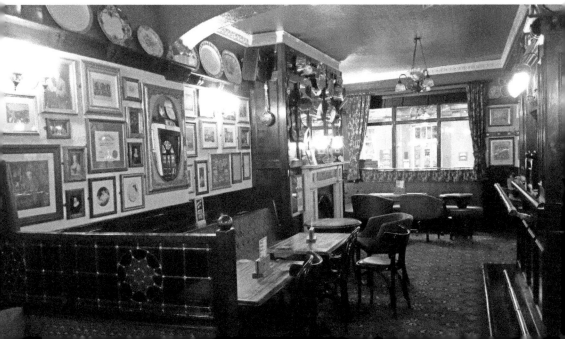

who had until recently been a proprietor of Scawin's Railway Hotel on Tanner Row, became the licensee of the Exhibition and changed the name once more to Dyson's Family and Commercial Hotel. Dyson painted his name in large letters on the façade of the pub but it seems the pub retained the name Exhibition in popular usage and official records.

In 1902 the Exhibition was considered a very good commercial hotel, consisting of six or seven bedrooms reserved for travellers. It had a coffee room with two small bars, a sitting room and a private kitchen. The Dysons were still in charge of the Exhibition when the First World War began, and Henry's twenty-eight-year-old son Henry George Alexander was drafted to the West Yorkshire Regiment. Although the Exhibition continued to prosper through the two wars, by 1967 the hotel was almost demolished under plans to build a dual carriageway inner ring road. Local opposition to the plan ensured the pub's survival to the present day where it still offers a pleasant Victorian-style experience.

3. GILLYGATE, Gillygate

A pub was first mentioned on this site as early as 1811 when it was known as the Waggon and Horses. Situated outside the city walls on Gillygate, the pub was an ideal resting place for those travelling by horse and provided plenty of space to visitors.

The intriguingly named Valentine Wilson was recorded as the landlord in 1816 and remained in control until 1838, over two decades in charge. He was succeeded by William Verity who held the licence until 1843 when Metcalf Dobson took over for a year. Arthur Dawson became publican in 1844 before being replaced thirteen years later by his son John Dawson. During the latter's tenure, the Waggon and Horses, sometimes referred to as the Cart and Horses, was often used by carriers as a stopping post on their journeys across the county. In 1855 for example, every Saturday Samuel Johnson used the inn before travelling to Craike, while William Harbisher journeyed to Huby. William Knowlson and Andrew Scott meanwhile utilised the York to Stillington route.

In 1876 Wright Battye took over for three years, having transferred from the Golden Slipper on Goodramgate while three years later Thomas Thompson became landlord and remained in charge until 1898. Thompson had an interesting encounter in May 1889 when Thomas Pumphrey stopped by his premises and shared a drink with the landlord. Thompson noticed blood on the visitor's face, who, despite his healthy disposition and jovial demeanour, had a severe wound on his neck. Pumphrey was subsequently hospitalised and charged with attempting suicide, heartbroken by the breakup of his relationship on the eve of his wedding.

By 1902 the Waggon, under John Swales, was only offering one room to travellers, although unusually for the period it did possess a Ladies Market Room for the sole use of female customers. In 1910 George Prevninger took over for a decade while James Brown was the landlord for fifteen years during the interwar period. Between 1935 and 1953 the Waggon and Horses was owned by the Coldrick family. The Grade II listed pub underwent an ownership change in April 2003 and was renamed the Gillygate after the road upon which it is situated.

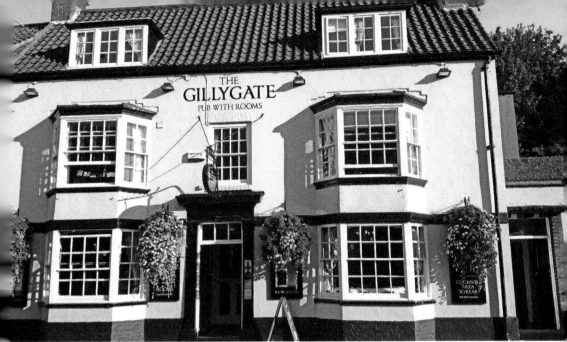

Above: The Gillygate.

Right: The Hole in the Wall.

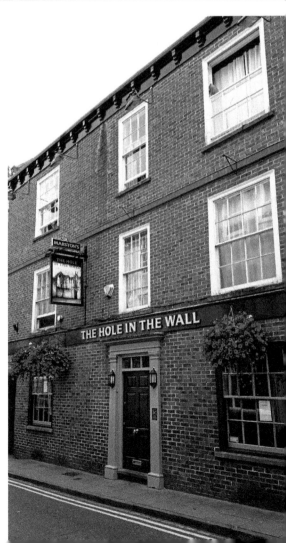

4. THE HOLE IN THE WALL, High Petergate

The descriptively named Hole in the Wall pub is situated on High Petergate, an ancient route first named in 1203 and only 50 metres from the ever-glorious York Minster.

An early reference to alcohol being purchased on this site is the opening of Wolstenholme's Dram Shop in 1869, a family run business that seems to have occupied the premises for a considerable period. The owner of the dram shop was George Wolstenholme, a prominent wine and spirit merchant who was listed as the owner of the premises as early as 1851. An indenture in York Minster archives dated 14 September 1849 sets out a lease agreement between the merchant and Revd John Bull, Prebendary of Fenton, to take over the house. The house was previously registered in 1828 to schoolmaster Joseph Wolstenholme, who appeared to inhabit the property for over two decades until George took over the reins.

By 1881 George Wolstenholme had retired and in 1887 the dram shop was in the possession of Thomas Blakey Haigh who renamed the shop Haigh's Vaults. In an 1893 advert Haigh declared his business had been established in 1800, and while there is no evidence to support this claim it should be noted the Wolstenholmes seem to have been active on the site since the 1830s at least. Haigh's advert promoted his pub's stock of whiskies, brandies and gin in addition to German-brewed lagers and pilsner beers. It also highlighted his business had previously been Wolstenholmes, which suggests the previous tenants had established a good reputation in the area. Haigh was a native of Huddersfield and lived at the premises with his wife Mary and children Lizzie, Alice, Beatrice and Herbert.

In 1902 the family relocated and the shop became the Petergate Wine and Spirit Stores and Bar. Although taken over by local brewers C. J. Melrose in 1909, the pub retained this identity until 1953 when it became known as the Board. As the twentieth century progressed it became clear that the building was beginning to show its age and had become unsafe to patrons – structural faults eventually caused the pub to close in 1978.

After a lengthy period of renovation the pub reopened for business on 9 December 1981 as the Hole in the Wall. A large board within the pub claims that this name refers to a dungeon that was found underneath the premises during renovation work in 1816, with workmen finding a room containing chains and iron manacles. It is probable this dungeon was located further up Petergate and closer to the Minster where another Hole in the Wall pub once stood. The incarcerated would be fed their meagre daily meals through holes in the prison wall, thus giving origin to the pub's name. It seems these two pubs have become confused over time.

A notable feature associated with the pub and worth exploring is Little Peculiar Lane, a small narrow alleyway next to the venue which leads to astonishing views of the Minster's west façade. This alleyway was originally used to provide access to the prebendal house situated to the rear of the building.

5. YORK ARMS, High Petergate

The York Arms is notable for its delightfully scenic position next to York Minster and stands partly on the former site of Peter's Prison, the complex that once housed the Minster's jail and gallows.

The York Arms traces its lineage to Carr's Coffee House, which is known to have been trading on the site in 1733. The business became Chapter Coffee House at some point prior to August 1789 when it was taken over by John Bletsoe. The establishment passed into the ownership of John Kilby, a notable brewer in the city who served as Lord Mayor of York in 1804 until he was forced to relinquish the property due to bankruptcy. In 1818 the coffee house was renamed the Eclipse and was listed as being under the control of Matthew Hick for a decade before his son-in-law Thomas Cuthbert became landlord in 1830. The Eclipse name was derived from a famous undefeated racehorse owned by the Duke of Cumberland and named for the great eclipse of 1764, the year the horse was born; it was a name the pub retained until 1834.

In 1838 the acclaimed architect James Pigot Pritchett was contracted to construct seven new houses on the site in a fan-shape terrace style, with the pub subsequently renamed the Board. Thomas Cuthbert remained the licensee during this period and temporarily brought back the Chapter Coffee House name in 1843. An indenture in the York Minster archives dated 1 July 1838 confirmed Cuthbert's lease of the building for forty years with an annual rent to the Dean and Chapter of £3 a year. Cuthbert's children, William, Hugh, Mary and Susannah, had been born and bred in the premises and it must have been upsetting when their father died in 1860, forcing the Chapter Coffee House to be advertised for sale by their mother Mary Ann. It was promoted as being in good condition with an excellent cellar and well adapted for business purposes.

George Mitchell took over the tenancy in 1861 and this is when the pub is first recorded as the York Arms. This name was derived from the city's coat of arms, an emblem featuring the red cross of St George adorned with five golden lions which represent the city's royal heritage. In 1885 the licensee was John Brown, although only

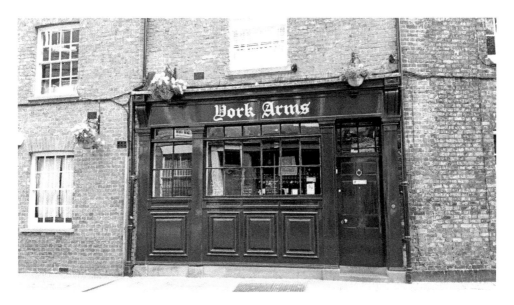

York Arms.

three years later he was declared bankrupt in court and forced to relinquish the pub. During proceedings Brown lamented his insolvency which he believed was caused by bad trade and competition. He was replaced by Luke Wilson and at the start of the twentieth century the landlord had changed once again, to Walter Bamford.

After short tenures by Tom Keld and Walter Blackburn, the Gravitt family took up residence in 1911, with first James Gravitt as landlord until Ada Gravitt took over four years later. In 1919 James Thomas Gravitt took over the pub and Amy Helen Gravitt served as licensee in 1932. Henry Ashton Campbell replaced the Gravitts later that year and remained publican until 1955. The property became a Grade II listed building in 1968 and was expanded in 1978 when a separate saloon room was created by knocking through to the adjoining property. The original pub today houses the lounge bar with a traditional snug room accessed by a sliding door.

The York Arms has become renowned in recent years for its paranormal activity. The pub is allegedly haunted by a ghost known as the Grey Lady, a reference to the grey blur of her apparition. The ghost is said to be attired in a medieval nun's habit and appears abruptly before mysteriously vanishing. A boisterous poltergeist has been reported locking doors and manhandling kitchen equipment and further paranormal activity is said to occur in the gentlemen's toilets.

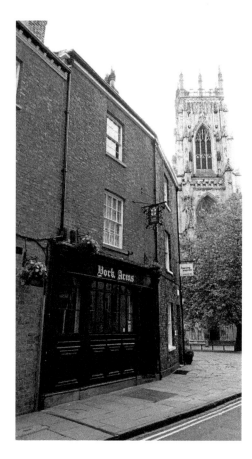

York Arms and York Minster.

6. GUY FAWKES INN, High Petergate

The Guy Fawkes Inn occupies an impressive site opposite the Minster, an inviting respite for the many tourists who frequent York's premier attraction. The inn was recently refurbished and now actively promotes itself as the birthplace of the notorious conspirator, reflected in the present name of the establishment. The inn proudly states that in 1570 it was in this building that Guy Fawkes was born, a claim often treated with caution by local historians, particularly as the present construction can only be dated to the early eighteenth century. A few metres across High Petergate stands St Michael-le-Belfrey church in which it is recorded Fawkes was baptised on 16 April 1570. The inn uses this event as evidence to bolster its birthplace theory, keenly noting the proximity of the two venues.

It is plausible that the schemer who has become synonymous with the Gunpowder Plot was born in the vicinity of the inn but unfortunately there is no solid evidence of where his birth actually occurred. It is commonly stated Fawkes's mother owned a small cottage that stood behind the building which now houses the inn; indeed a cottage still remains in situ at the rear of the inn, providing guest rooms to visitors, and although this dates from the eighteenth century it does possess earlier foundations. It should be noted a York Civic Trust plaque is positioned on nearby Stonegate claiming an alternative birthplace of Fawkes and contradicting the inn's claim.

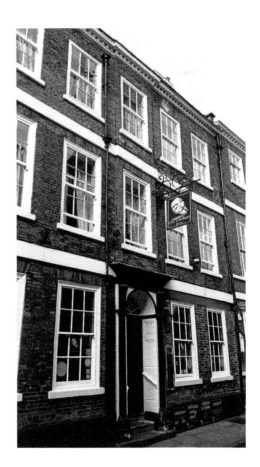

Guy Fawkes Inn.

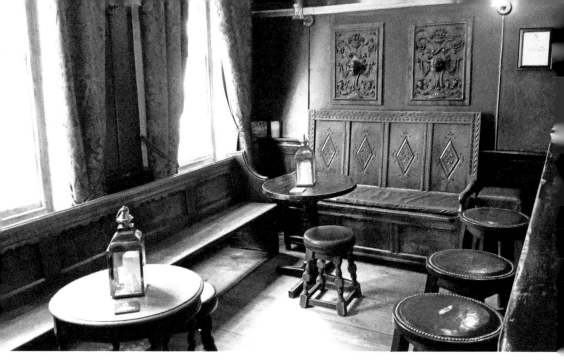

Front Room, Guy Fawkes Inn.

The building that currently stands on the site was completed in 1707 when it was constructed for John Bowes and his son George, one of a row of three houses erected. The inn has retained its simple yet alluring Victorian staircase, above which stands a small panel of painted glass dating from 1801 featuring the arms of York and the House of Hanover. Although the premises was used for purposes other than a pub during the Victorian period, by 1905 it was listed as Wasling's boarding hotel and was operated by Maria Wasling.

By 1911 Charles Young was in charge of the property and continued to trade as a boarding house. Within a decade the business was being run by his son Charles Henry Young and renamed Young's Hotel, a name it kept for the remainder of the twentieth century. Young's also attempted to capitalise on the Guy Fawkes link, with signs often painted to state 'The Birthplace of Guy Fawkes 1570.' The inn underwent a major refurbishment in 2008 when it was rebranded the Guy Fawkes Inn, complete with gas lamps and open flame candles in place of traditional lighting, an effect that creates a wonderful ambience in which to revel in the history of the building.

7. THOMAS' OF YORK, Museum Street

Thomas' of York is a Grade II-listed building on Museum Street, standing 50 metres from the Minster and occupying the halfway spot between the medieval masterpiece and Lendal Bridge.

The present construction was erected around 1858 when the site was purchased by William Thomas, a notable hotelier who had run a premises on Low Petergate for five years. The site for his new hotel, which he opened in 1861, had previously been occupied by Etridge's Royal Hotel, a building of eighteenth-century provenance that

had been demolished in order to improve the approach to the new bridge. The crossing opened in 1863.

Previous establishments which stood on the site had long attracted notable clientele from the higher echelons of society, aided by its location in an affluent part of Georgian York. King Christian VII of Denmark stayed in a hotel on the site during his progress in 1768 while two decades later another royal visit witnessed George, Prince of Wales and future George IV, stay at the same inn. It is probable that these visits were a factor in Thomas Etridge adopting the name Royal Hotel when he later took over the premises to increase the prestige of his business. Etridge was a notable member of the local Whig party and in 1818 his hotel hosted the formation of the York Whig Club. This political movement was founded with the aim of supporting the 'constitution of Great Britain, as established by the Glorious Revolution of 1688' and would be locally active during the nineteenth century. Etridge, who served as Sheriff of York in 1832, retained ownership of the hotel until its aforementioned demolition in the 1850s.

William Thomas owned the new hotel until 1876, the year before his death, when he sold his business to a Bedale brewer called Thomas Lightfoot who retained the name Thomas Hotel. By the turn of the century, when it became the property of John Smith's Brewery under the guidance of John Wilkinson, the hotel was noted to have eight bedrooms of which five were reserved for travellers, two drawing rooms, a coffee room, a bar and a billiard room. In 1909 the publican was John William Holliday but he died within a year, with the licence transferring to his widow Annie Marie. In 1911 Mrs Holliday was living at the hotel with her adult daughters Beatrice and Mabel, who were employed as her assistants, and her teenage daughter Athene, a railway clerk. The youngest Holliday children Tom and Eric were still in school. Annie Marie remained in control of the hotel until the Second World War. After a closure in 2010 the hotel reopened under the name Thomas' of York in 2012. The Victorian doorway still remains one of York's finest entrances to any building and features ornamentation displaying the Thomas Hotel name.

8. YE OLDE STARRE INNE, Stonegate

Ye Olde Starre Inne is an atmospheric, wood-panelled pub based off Stonegate that lays the best claim to being the 'oldest pub in York'. Many pubs throughout York proclaim themselves to be the city's oldest watering hole, and while many of these undoubtedly inhabit buildings that predate the Tudor period, it is certain that the Olde Starre possesses the city's longest continual licence.

While portions of the building date to the mid-sixteenth century, the Olde Starre's licence has been traced to 1644, a significant year in York's tumultuous history due to the city's role in the English Civil War. In the aftermath of the Battle of Marston Moor wounded soldiers were placed in the Olde Starre, with the cellar in particular operating as a makeshift hospital and morgue. The landlord at this time was a renowned royalist William Foster. After the Parliamentarians breached the city walls they took up residence in Foster's pub, a situation that must have been particularly galling for a man avowedly loyal to the crown. It is possible many soldiers died in the temporary hospital located in the pub and some still claim to have heard their anguished cries. These alleged screams have become one of York's better known ghost stories.

That same year the pub was mentioned as the Star Inn in connection with printer Thomas Broad, a noted Parliamentarian and Puritan supporter who was recorded as staying on the premises. Broad regularly published pro-Roundhead propaganda from his base in Stonegate and became a noted personality in the city. By 1662 the Star Inn was operating as a successful coaching inn and was purchased by Thomas Wyville for £250. It seems that Wyville was holding the pub in trust for Henry Thompson, a prominent local figure who served as Lord Mayor of York in 1663 and Deputy Lieutenant of Yorkshire in 1668. The inn was inherited by Thompson's son Edward in 1683; the latter would later be recognised as the grandfather of James Wolfe, the lauded British Army General dubbed the 'Hero of Quebec' for his endeavours in Canada. During the early eighteenth century the inn was frequented by Freemasons, with records showing the pub hosted meetings of a Freemasonry Lodge in 1725.

As a bustling coaching inn the Star possessed substantial stabling and a large yard in front of the premises which would have opened onto Stonegate. A large well was situated in the courtyard and supplied fresh water to the neighbourhood, a role it played for generations. As the city grew the street begun to be redeveloped and gradually the inn was concealed behind new buildings, accessible only via an alleyway as remains the case today.

In 1733 licensee Thomas Bulman, concerned that concealment of his pub was adversely affecting trade, conceived a novel idea of publicising his inn to passers-by. Bulman agreed to pay his neighbours George Ambler and John Moore five shillings a year to erect a gallows sign on their opposing properties which would span the street. The idea proved to be a success and the sign has remained an iconic landmark on Stonegate to the present day. Bulman proved to be as crafty as he was innovative for he decreed that the sum of money he paid his associates could only be spent whilst in his company, a transaction that presumably took place inside his pub. By 1798 the Star Inn was presided over by Robert Harvey while by 1816 it was run by William Knapton who had purchased the inn for £850. By 1828 Thomas Hawkes was the publican.

In October 1831 the Star Inn was advertised for let and promoted as possessing a good kitchen, taproom, two parlours, a large dining room, a bar, a pantry and spacious wine and ale cellars. The inn also provided twelve rooms for lodgers. The letting agent announced that the listing was 'one of the most eligible offers ever submitted to public notice'. It was again listed in December 1837 as having extensive stabling and a brewhouse.

In 1851 the licensee was John Wood whilst in June 1855 new landlord Francis Palmer advertised he had taken over and was selling 'superior home brewed ale'. In 1858 the new licensee was the youthful Samuel Abbey who was just twenty-six years old. Abbey retained control until his death in 1874 and a short while later the inn was in the hands of Henry William Watson. By 1881 William Horner Boddy was recorded as the victualler, having left his position at the Navigation Tavern in Skeldergate. Boddy, a qualified chemist, was an influential licensee and served as Secretary to the Licensed Victuallers Society. He remained in charge until his death in 1894 and had proudly displayed his name on the gallows sign which spanned Stonegate, which read 'Boddy's Star Inn'.

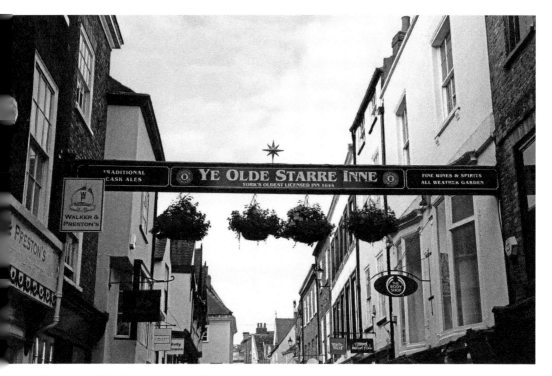

Above: Ye Olde Starre Inne gallows sign above Stonegate.

Below: Ye Olde Starre Inne.

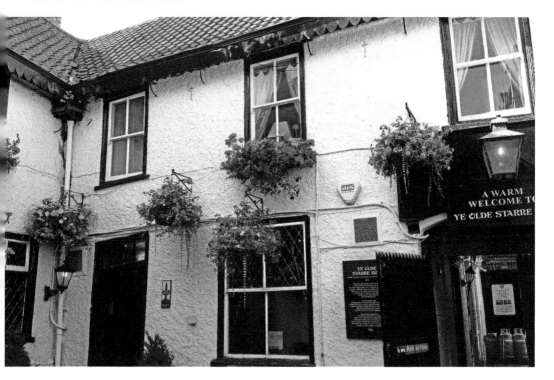

A conspicuous feature of the inn from this late Victorian period is the internal Brett Brothers leaded glass screen which is situated close to the main door, displaying both the Brett Brothers and Star Inn name along with the city's coat of arms. The Bretts were local brewers and maltsters who owned the premises during the 1890s. In 1895 Peter Arthur Hatfield was the licensee followed in short succession by Thomas Thompson and Mark Midgley.

By 1909 the landlord was Henry Smith, better known as Harry. The Smith family remained in charge of the inn for almost half a century. Eager to capitalise on the inn's history the name was changed by the Smiths in 1923 from Star Inn to the more evocative Ye Olde Star Inn. Harry remained the primary licensee until 1938 when Maud Smith became landlady prior to the outbreak of war. The inn again played host to soldiers during conflict when it was a regular haunt for troops stationed in the city during the Second World War, three centuries after the English Civil War brought an army to the inn's courtyard. After the war Walter Smith, son of Harry, was listed as the licensee and was in charge when the inn became Grade II listed in 1954, an acknowledgment of the pub's remarkable architectural history.

The pub today is now displayed as Ye Olde Starre Inne, the medieval style spelling unsubtly demonstrating the inn's 400-year old lineage. The origin of the name in its various forms is uncertain but is often thought to have emanated from one of two possible sources. One theory is that the name refers to the biblical Star of Bethlehem which is stated to have assisted pilgrims in finding their way along Stonegate to York Minster. The second possible explanation for the name is an allusion to King Charles I who was sometimes described as the Old Star. It should also be noted that the crest of the Worshipful Company of Innholders is a star of sixteen rays, an emblem which may have influenced the name of this particular inn.

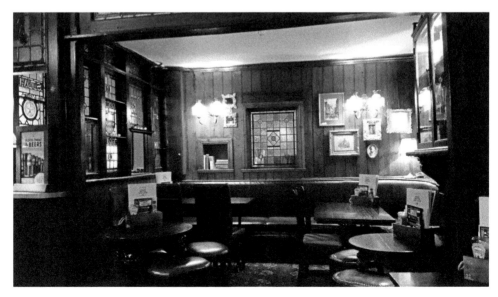

Former bar room, Ye Olde Starre Inne.

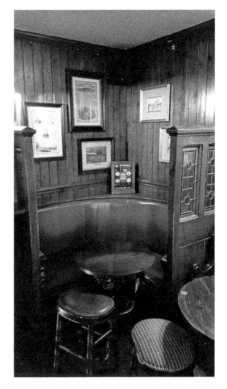

Wooden booth, Ye Olde Starre Inne.

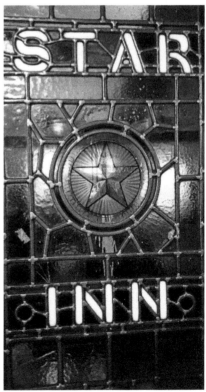

Late-Victorian stained glass, Ye Olde Starre Inne.

9. PUNCH BOWL, Stonegate

The Punch Bowl on Stonegate is notable for its extraordinary black and white Mock Tudor exterior, an aesthetically pleasing frontage that has become popular with tourists. Although designed to appear of sixteenth century origin, the Punch Bowl's magnificent façade was unveiled as recently as 1931. The pub had suffered a crippling fire in 1930 and was refurbished by owners Tadcaster Tower Brewery, who shrewdly pulled down the old brick front and replaced it with jettied timber-frames. The Grade II listed pub does however possess a history that far precedes the 1930s and is one of York's five oldest drinking establishments.

A coffee house stood on the present site in 1675 and this date is intricately commemorated on the carved bargeboard which adorns the top of the Mock Tudor façade. This site was first known as a pub when it was licenced in 1761, trading as the Golden Punch Bowl under the tenancy of Mrs Chaddock. The same year the Punch Bowl Lodge of Freemasons received a warrant which allowed the group to organise and constitute a formal lodge. Records show a meeting of Masons was held in the Punch Bowl on 18 January 1762 whilst the warrant was issued on 10 July; the lodge ceased to exist by 1764.

The Punch Bowl name is of seventeenth century political origin and proved to be a popular moniker for pubs across the country which were frequented by supporters of the Whig Party. It was often recorded that Whigs were known for drinking punch whilst their opposition the Tories had preference for sack and claret. The Whig fondness for punch often led to the pubs they patronised adopting the name Punch Bowl as a means of publicising the outlet's political leanings.

In 1765 an old Tenor Bell clapper from the Minster was presented to the pub, intended to act as a support for one of the oak beams. The heavy clapper remains a feature of the pub, visible in the rear lounge. The pub has long been connected to the Minster's bell ringers and the old bell component is indicative of this relationship. In December 1770 a local vintner named John Dalton was declared bankrupt and had his case heard at Golden Punch Bowl, where he had served as landlord between 1763 and 1766. By 1770 Thomas Grice was in charge of the Golden Punch Bowl and resided at the inn for almost two decades.

The pub enjoyed a rowdy reputation during the nineteenth century and was a popular haunt in the city. In 1801 the incumbent landlord George Stephenson died aged thirty-one and by 1804 John Riley was the resident publican. In 1813 it was recorded that the pub put three albino children on display, charging punters 6d to view the young siblings. The landlord in 1821 was Thomas Joy who held the licence for over two decades until his death in 1845 aged eighty. In 1832 a raucous mob of Tory supporters broke into the Punch Bowl loudly decrying voting irregularities that favoured the Whigs. Such an occurrence only served to emphasise the pub's political stature.

In 1849 the licence was held by Elizabeth and Jane Joy, the daughters of the previous landlord, although just two years later the victualler was former schoolmaster Thomas Fox of Halifax. Fox remained in charge of the thriving pub for over fifteen years and lived with his wife Martha and grandson Arthur. In January 1856 the York

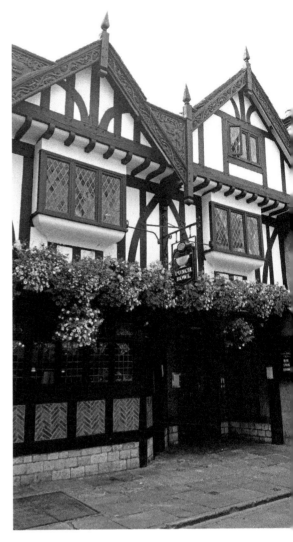

Right: Punch Bowl.

Below: Punch Bowl gables.

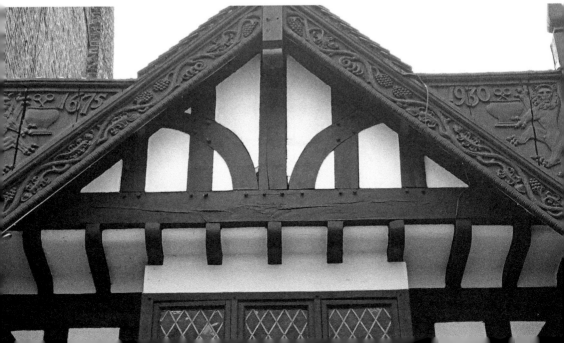

Brotherly Society held their centenary dinner at the Punch Bowl while in July 1860 Fox's establishment hosted the annual dinner of the Kingston Unity of Odd Fellows who were noted as spending the evening in a 'convivial manner'. In April 1862 a theft was reported to have occurred at the Punch Bowl when a man named Squire Lumb was accused of stealing a diamond ring from Edwin Sharp. Thomas Fox stood as a character witness for the accused and testified that he had allowed Lumb to stay at his home while the latter visited the city as he found him to be an honest and well-behaved man. Lumb was nonetheless sentenced to two months hard labour after pleading guilty.

The pub went through a series of spells in the possession of John Hogg, James Allen and William Hanforth while in 1880 the Punch Bowl's notorious reputation came to prominence when twenty-four 'immoral' persons were found to be dwelling within the inn. Hanforth was charged with keeping a disorderly house and fined. Burnley-born William Heathwaite took over the pub in 1886 and in October 1888 advertised for a 'young lady pianist-vocalist' to live and perform in the pub, underlining the Punch Bowl's penchant for entertainment.

Liverpudlian Robert Murphy was landlord by 1909 and held the licence until about 1914. Thomas Riley was publican during the war and after hostilities had ceased Edward Hall Newman was the first of three short-term licensees, followed by juror Alexander Northop and Robert Pallister. Walter Peake took over the running of the Punch Bowl in 1928 and held it until 1939 and the outbreak of the Second World War when Helen Peake was landlady.

Tenor bell, Punch Bowl.

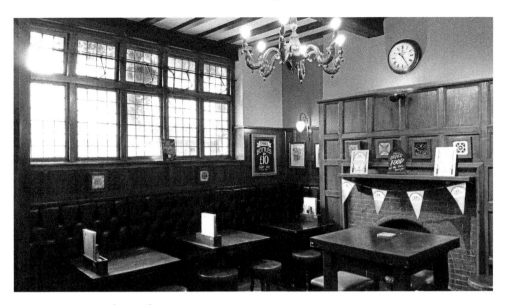

Front room, Punch Bowl.

The Punch Bowl plays host to several ghost stories. A popular tale is that of the young woman who rejected the advances of a drunken patron. The man chased the terrified girl around the pub before cornering her in one of the rooms where he proceeded to strangle her to death. The tragic screams of the victim are still said to ring throughout the pub in the dead of the night. Another frequently recounted tale is that of a landlord who perished during one of the fires that devastated the pub during the Victorian period. The landlord is often said to be seen in the cellar, nonchalantly going about his job as though he was still alive.

10. OLD WHITE SWAN, Goodramgate

The Old White Swan is undoubtedly one of York's historic pubs, situated in the centre of the city with a compelling past that has ensured its consistent popularity across the last 300 years. The current part-timber, part-brick complex is an amalgamation of various structures which have been erected on the site over the last four centuries. The result is an impressive assortment of medieval and Georgian architecture that has combined to create a traditional and atmospheric public house. The oldest surviving section is the two-storied centre range, which is set back around 50 feet from the street and dates from at least the sixteenth century. It should be noted the pub does even possess a minor Roman connection; a column has been preserved under a glass panel albeit not in situ.

The earliest known record of a licence is 1703 which makes the White Swan the third oldest pub in the city in terms of a continually-held licence. In 1712 the pub was owned by the church and was notable for containing entrances which opened onto two different streets, namely Petergate and Goodramgate. Two neighbouring parishes, Holy Trinity Kings Court and Holy Trinity Goodramgate, claimed the right

to charge the inn an annual rent of £12, a circumstance which proved to be costly for a landlord having to appease two creditors. The landlord's resolution to this financially unsustainable situation was to paint a white line through the courtyard and kitchen, symbolically dividing the building between the two parishes and setting an artificial boundary. The inn's rent was thus split equally between the two churches.

During the early eighteenth century religious and political tensions were heightened throughout the country due to the Jacobite threat. In 1723 York was amongst the many cities subjected to desperate searches in government attempts to uncover papists, Catholics who declared loyalty to the Pope in Rome as opposed to the Church of England. It was recorded that two parish constables spent the sizable figure of £1 on ale in the White Swan whilst keeping a watch for suspected papists thought to be frequenting the inn. The pub is the subject of a ghost story connected to this alleged papist activity; it has been stated that chairs rearrange themselves into a circle overnight and the fire is often found inexplicably relit. It would seem the pub is host to a group of catholic ghosts frantically plotting their escape to France, a situation that would have occurred across the nation in the early eighteenth century.

In 1742 the premises was taken over by William Barwick, licensee of the Sandhill pub in Colliergate. Barwick chose to alter the name of his new acquisition to reflect his proprietorship, renaming the inn the White Swan and Sandhill, a name it would retain until 1786. Two side wings were constructed in the mid-eighteenth century which substantially increased the size of the complex, which at one time was acknowledged to contain as many as nine separate sections. These brick additions extended from the original timber-framed building to the street, effectively creating the enclosed yard still extant today. It is known that many of these buildings were operated separately to the inn, with one playing host to a barbershop for a period of time. The White Swan also occasionally hosted a poultry market within its confines, with farmers travelling into the city to sell their goods to the city butchers. Other temporary uses of the White Swan buildings were a pigsty and a hayloft.

In 1771 the Goodramgate entrance was pulled down and rebuilt, presumably improving access to the inn. By 1795 the White Swan's address was recorded for the first time as Goodramgate alone, perhaps indicating the quality and popularity of the work undertaken on the entrance two decades earlier. The Petergate entrance would gradually become concealed by rebuilding to the extent that it is no longer noticeable.

As a form of entertainment the pub often hosted unusual events and on 5 August 1781 the pub's landlord William Featherstonehaugh displayed the world's tallest man Patrick Cotter O'Brien. The twenty-one-year-old Irishman stood an astonishing eight feet tall and the landlord charged bewildered spectators one shilling to view the giant in his pub. It was a profitable event for both the landlord and O'Brien, who would take his show around the world. This penchant for unusual exhibitions is further evident from a bizarre incident in 1825 when a man attempted to devour 10lbs of tripe in the inn, although it was stated he only managed 7lbs.

During the late eighteenth century the White Swan was a successful coaching inn and provided amenities to many travellers. In 1798 a passenger carrier was known to depart and arrive at the White Swan; George Squire operated the Durham, Newcastle

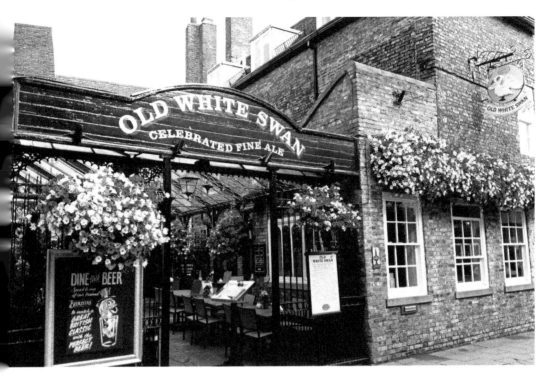

Above: Old White Swan.

Below: The fireplace, Old White Swan.

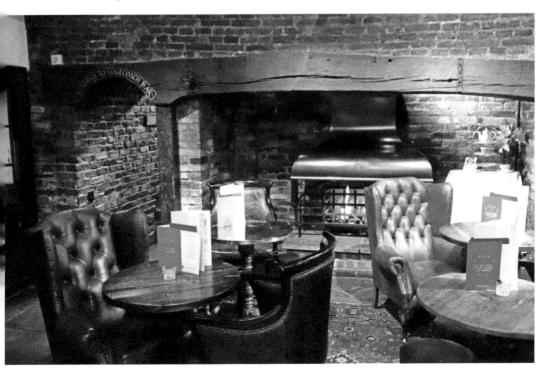

and Glasgow route and arrived on Thursday night before departing the next morning. In 1803 Mark Thornton was recorded as arriving from Helperby on Saturday morning and returning the same afternoon while in 1818 Samuel Balmbrough was operating a route to Easingwold every Saturday. This legacy is still evident today by the four mounting steps situated in the courtyard.

In 1803 the White Swan was run by Joseph Davis and by 1818 by Richard Cariss. In 1830 John Ruddock was the licensee but he announced his retirement from the trade a year later via an advert in the local press. Ruddock stated that he had 'declined the business of innkeeper' and intended to become an auctioneer. By 1838 Sarah Scawin had taken over after the death of her husband the previous year shortly into his tenure. In 1843 the licence was held by Robert Wilson and he would remain in charge of the White Swan for over thirty years until William Hornsey took over. In 1862 local stained glass artist John Ward Knowles was recruited to paint a sign for the White Swan and it is this design that is roughly retained today. After James Berwick became licensee in 1885 the name was altered with the addition of the prefix old, intended to emphasise the White Swan's significant heritage. It retains this name today.

Towards the end of the reign of Queen Victoria the Old White Swan briefly came under the rule of two women. In 1889 Ann Elizabeth Batty was the landlady with Margaret Barnes taking over four years later. Mrs Barnes remained in place until 1898 when Charles Joughin and George Gosley took over in quick succession. In 1902 while Edward Reginald Halstead was the landlord the Old White Swan was recorded as having nine bedrooms, suggestive of the significant size of the pub. Only one of these rooms was made available to travellers which indicates the White Swan was trading primarily as a pub by the turn of the century rather than a traditional inn.

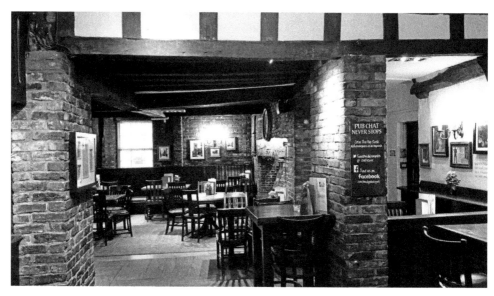

The Tudor Room, Old White Swan.

Stagecoach bar entrance, Old White Swan.

Mounting steps, Old White Swan.

11. THE SNICKLEWAY INN, Goodramgate

The Snickleway Inn has been operating since at least the eighteenth century and has developed a reputation as one of Britain's most haunted pubs. It is probable a pub called the Painter's Arms existed on the site as early as 1769, operated by Edward Powell. His son John purchased the property for £100 in 1778 and it stayed in family hands until the 1840s. The nearby yard is still referred to as Powell's Yard.

By 1818 the pub was known as the Square and Compass and run by Sarah Gill, although it was occasionally referred to as the Mason's Arms. This was an allusion to the tradesmen's tools which featured in the original pub sign, often considered to be a traditional Masonic symbol. By 1830 Richard Powell was listed as the publican and retained this role until at least 1838. In September 1850 an elderly gentleman named Thomas Atkinson accused a young woman of disreputable character named Catherine Herbert of stealing a watch along with a sizable quantity of gold and silver. The couple had been together at the Square and Compass where they dined on beef steaks and ale before Atkinson fell asleep due to drunkenness. When he awoke both the girl and his possessions were missing. The case was dismissed by the judge as there was a lack of evidence to convict and the local press lambasted Atkinson as a 'silly old man' for his behaviour in cavorting with young women.

Wine and Spirit merchant William Cooper took over the property in 1851 when he paid £360 for the property. From 1852 until 1891 the pub was recorded as the Board, although it was informally referred to as Cooper's Vaults after its owner. In 1872 Robert Wood took over the licence until 1883 when Edward Staines became the new landlord. Staines was around thirty-five years old when he took over and was originally from Norfolk. He operated the pub with his wife Mary and their two young children, Ernest and Charles. By 1896 Staines had changed the name of the pub to the Angler's Arms, a name by which it was known for the next century.

John Graham briefly became landlord in 1898 before fifty-seven year old George Marley and his wife Mary Jane took over. George died in 1910 and Mary Jane was listed as proprietress in 1913 when she was seventy-seven years old. Her daughter Lilly Marley was listed as a manageress and they also employed a servant named Flora Boggitt. After the war the Angler's Arms was bought by the Linfoot family, with first George and then Arthur listed as publicans. In 1929 Maurice Shaw took over and remained in charge for over two decades, relinquishing control in 1953. The pub remained popular during the twentieth century but was renamed the Snickleway Inn in 1994, an attempt to capitalise on the recent emergence of the term snickelway to describe the city's many snickets, ginnels and alleyways.

The Snickleway is often featured on 'most haunted' lists and apparently plays host to a varied assortment of paranormal visitors. One spirit is detected only by the strong fragrance of lavender that betrays the ghost's presence while a small Victorian girl has also been spotted on the stairway casting her gaze upon drinkers. The popular explanation for her appearance is that the young girl was a resident of the pub and one day carelessly raced down the stairs and out into the busy street, oblivious to the horse and cart delivering the day's beer. Despite her violent and tragic death the spirit's demeanour is stated to be friendly and amiable. Another spirit which dwells in the cellar is considered to be a malevolent presence who plays havoc with the bar equipment.

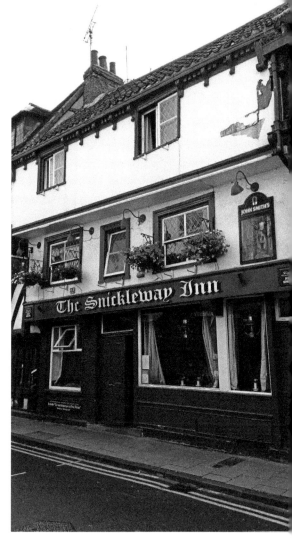

Right: The Snickleway Inn.

Below: Timber-framed alcove,
Snickleway Inn.

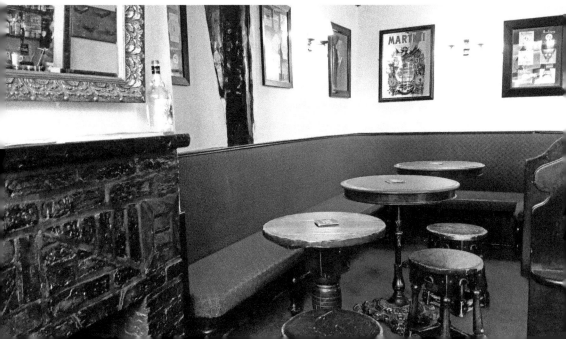

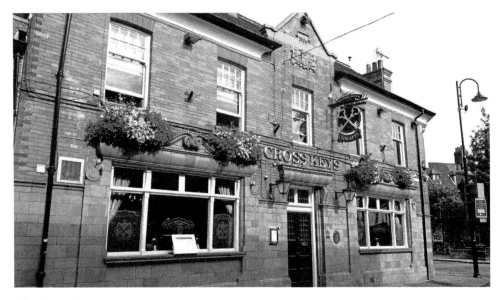

The Cross Keys.

Lastly the Snickleway Inn contains the ghost of the unfortunate Marmaduke Buckle. The story states that Marmaduke was born in 1697 to a wealthy family but found himself isolated and persecuted as a youth due to a crippling defect he suffered at birth. The youth's descent into depression caused Marmaduke to hide away in a room on the top floor of the building where in 1715 he hanged himself from a wooden beam to escape the taunts from the street below. The opening of doors and the lighting of lamps in his former room betray Marmaduke's presence, destined to remain seventeen years old forever. Records suggest a Marmaduke Buckle did exist during the early eighteenth century although there is no evidence of an early death consistent with the ghost tale.

12. CROSS KEYS, Goodramgate

The Cross Keys pub stands in the shadow of York Minster's lauded eastern front, a location which offers the pub's patrons enviable views of the largest medieval stained glass window in the country. The present pub is situated on the corner of Goodramgate and Deangate, a thoroughfare partially created by the destruction of the original Cross Keys pub in 1902.

A public house had stood on the site for the duration of the nineteenth century and was mentioned as early as 1783. This pub stood on land originally owned by the Minster, a fact denoted by the longstanding usage of the name Cross Keys. The Minster is dedicated to St Peter who, as keeper of the keys of heaven, is often represented by an emblem of crossed keys. This symbol also features prominently in the arms of the See of York and is used to represent the incumbent archbishop.

The landlord in 1818 was John Turner while ten years later Richard and then Joan Broadmead held the licence. By 1838 Robert Coates took over the Cross Keys and remained the publican until 1851. The Mountain family were recorded as licensees

for over quarter of a century between 1851 and 1883. George and his wife Hannah Mountain of Clarence Street were initially in charge alongside their twenty-one-year-old son William. By January 1852 William became publican in his own right and ostensibly remained in charge until 1872. The new landlord advertised in the local press that he offered an extensive and well-selected stock of wines and spirits. In 1854 two of William's servants were arrested for stealing items such as candles, soap and sugar as well as four bottles of gin and brandy. In August 1863 a fire broke out in the pub after clothes were left hanging in front of the kitchen fire. The only casualty was the family parrot which was kept in a cage in the kitchen.

In 1872 Elizabeth Mountain was listed as the sole licensee of the pub until John William Mountain replaced her before 1879. The pub finally passed out of family hands in 1883 when Henry Mawer took over for a short period. In 1888 an indenture between James Melrose of Clifton Croft and the Dean and Chapter of York enabled the former to acquire the site for a fee of £850, along with the yard and outbuildings. Melrose was a noted politician who served as alderman for over ten years as well as becoming Lord Mayor in 1876. The license was held by John Stephenson until 1895 until his wife took over.

In 1902 the pub was recorded as having five bedrooms, all of which were occupied by the Stephenson family, and was not considered to be kept in a clean or tidy state. The sole lavatory in particular was regarded as filthy. Fortunately planned developments of Goodramgate and the construction of Deangate resulted in the demolition of the decrepit building and cleared the path for a new pub to be erected nearby. In October 1902 CJ Melrose & Co Brewery gained permission to begin work and the new Cross Keys pub was completed in 1904, an act commemorated by ornamentation on the red brick façade.

In 1920 John and Ann's son Benjamin Stephenson took over from his mother whilst his younger brother Arthur was in charge between 1930 and the outbreak of the Second World War. The Stephensons had been in charge for half a century. In 1986 the Cross Keys was renovated and the original Edwardian interior was removed to combine the separate bars into the one single room still currently in use.

13. THE GOLDEN SLIPPER, Goodramgate

The Golden Slipper is regarded as one of the city's leading historic public houses with an aesthetically pleasing exterior which instantaneously highlights the diverse heritage of this unique Grade II listed building. The Slipper's façade is a combination of Victorian brickwork and medieval timbering, the result of an amalgamation between two adjoining properties during the nineteenth century.

The north eastern section of the building, with its prominent gables and jettied floors, dates to the late-fifteenth or early sixteenth century and is representative of the style of the early Tudor period. This part of the pub contains three storeys with the highest floor significantly overlapping the Royal Oak next door. The explanation for the considerable projection of the top floor is that it once stood above an alleyway which passed underneath. This walkway became concealed when the adjacent property was built during a later date. The two-storeyed south western portion of the Golden Slipper public house was erected in the late nineteenth century using red bricks typical of the period.

A notable feature inside the pub is evidence of a 'coffin drop', an architectural peculiarity with origins in the medieval period. It was considered to be a bad omen for deceased members of the premises to leave their home by the front door therefore an opening was required to allow a body to be transported out of the building by a side passage. This coffin drop is noticeable in the Golden Slipper due to a lowered ceiling and presumably would have opened into the alleyway which once stood alongside the inn.

A pub on this site was known to be trading as the Shoe or Shou as early as 1782 and records indicate this name was used until at least 1795. The pub was trading as the Slipper by 1818 and used this name until 1823 when it added the prefix Golden. The licensee in 1821 was recorded as Mary March and her pub was connected to a notable murder case that year. William Brown was hanged in the new city jail on 21 April for robbing John Armstrong by the river. It was recorded that the victim was 'returning from having a few at the sign of The Slipper in Goodramgate' when he was severely beaten and thrown into the river until his body was 'stiff and stagnated with cold'. Brown's executioner was John Curry, an experienced hangman who was heavily intoxicated and needed assistance in completing the job.

In April 1826 the pub again played a noteworthy role when the *York Herald* reported that 'a meeting was held at Mrs March's, at the sign of The Slipper in Goodramgate' whereby the bricklayers agreed to strike in protest at decreased wages. By 1828 the Golden Slipper was registered in the name of John March who retained control until around 1871, over four decades of proprietorship. In February 1855 a newspaper report of a Licenced Victuallers Association meeting at the Golden Slipper lavished praise on March and his hosting of the event, stating his 'repast was of the most

The Golden Slipper.

The Golden Slipper medieval corridor.

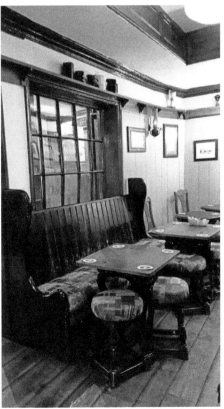

The Golden Slipper sports room with
original exterior window.

sumptuous character' and 'the wines too were of the best quality'. By 1872 Wright Battye was landlord until John Marshall took over in 1876 and Barnabas Marshall of Knaresborough in 1879.

In 1886 a thirty-two-year-old wool merchant called Frederick Smith Jackson became the publican along with his wife Elizabeth. An advertisement for the Golden Slipper Hotel shortly after the ownership change announced Jackson, credited as a licensed victualler and wine and spirit merchant, as the purveyor of choice wines and spirits in addition to sparkling home brewed ales and stout on draught. Jackson also advertised his stocking of cigars of the very best brand. In June 1892 some of Jackson's cigars were reported stolen with the accused Fred Wilson sentenced to one month's hard labour for his crime.

By 1902 the Slipper was known to have five bedrooms although two were considered to be very damp and uninhabitable. The pub possessed a smoke room and a taproom in addition to a dram shop. During this period the Jackson family consisted of Frederick, his wife Elizabeth, their young son Frederick William and Elizabeth's teenage nephew William Mountain. Jackson remained in control of the Golden Slipper until his death in 1917. He had been the licensee for over thirty years.

Renovations in 1983 uncovered a medieval leather slipper which had been built into the pub's wall at some point in its past. This superstitious custom has become known as concealment shoes and academics believe this was a ritual carried out by medieval occupants of houses to ward off evil spirits and demons. It is possible that this slipper was known to previous generations of tenants and is the origin of the pub's name. The slipper is now on display in the pub in a protective glass case located directly beneath the coffin drop.

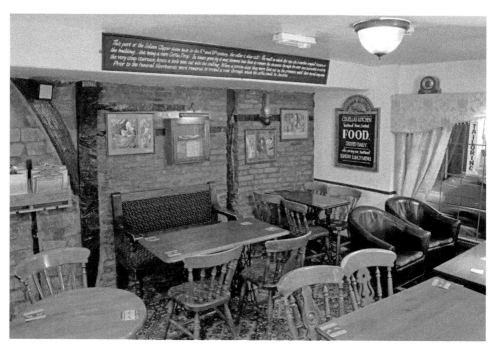

The Golden Slipper front room with coffin drop.

14. ROYAL OAK, Goodramgate

The Royal Oak on Goodramgate possesses a charming Elizabethan-style exterior that compliments the pub's lengthy past. The pub stands three storeys high and contains significant timber framing dating to the fifteenth century.

Although the Royal Oak proudly displays a sign purporting to be a seventeenth-century inn it is only possible to trace the origins of a public house on this site to the late eighteenth century. In 1783 it was known that Charles Popplewell was running an establishment named the Blue Pigg until John Furness took over in May 1794 and renamed his pub the Blue Bore or Boar. The licence was purchased by John Kilby in 1797 although the one-time Lord Mayor of York was forced to relinquish control in 1819 upon his bankruptcy. The rights to the pub were publicly auctioned at a sale held on 31 August 1819 in the Robin Hood pub in Castlegate with Thomas Belt securing the building with a bid for £460. By 1825 it had become known as the Royal Oak.

By 1828 the landlord was Robert Bowman, who remained in place for two decades, followed by Robert Bateman and his wife Ellen in 1849. The Bateman family also included the couple's teenage children Mary Ann, Robert and Jane. After Robert's death in 1858 Ellen continued to run the Royal Oak for another decade. By 1871 Ellen Bateman's son-in-law William Shutt of Harrogate became primary licensee, taking over the family business after his marriage to Jane Bateman. After his death in 1881 his widow took over the pub just as her mother had done twenty three years earlier.

The Royal Oak returned to the Bateman name in 1886 when Robert Bateman Junior, son of the erstwhile landlord and brother to Jane, took over the premises with his wife Elizabeth. It must be assumed that the pub meant a considerable deal to Robert and sentimentality may have played a role in the qualified butcher changing trades. Unfortunately Robert died shortly after becoming the publican and in similar

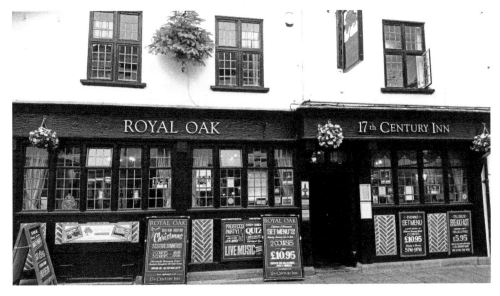

The Royal Oak.

circumstances to his father and brother-in-law, the pub passed over to his widow Elizabeth who was assisted by their son Albert Bateman.

In 1895 the pub passed out of the Bateman family for the first time in almost half a century when Walter Dodgson took over the Royal Oak, coinciding with the purchase of the pub by John J. Hunt brewery in 1894. Leonard Coates was listed as the publican by 1898 and moved into the pub with his large family, including wife Eliza and children George, Walter, Clyde, Elsie and Beatrice. Leonard was landlord until his death in 1902 when Eliza became landlady. Coates erected a large wooden sign above the doorway when he took over that simply announced his name, a feature that was still in place after his death. Henry William Hutton became the licensed victualler in 1909 and remained in place until after the First World War.

Elizabeth Harling was landlady from 1920 until 1932 when the pub temporarily closed to undergo a renovation. Owners John J Hunt Brewery, who operated from a large brewery behind the pub on Aldwark, refurbished the interior in 1934 and overhauled the exterior to appear Mock Tudor or Elizabethan. Noticeable features are is the wood-heavy design of the appropriately named Oak Room and the small snug with U-shaped seating. The pub is now considered a CAMRA Heritage Pub due to its surviving interwar refurbishment and is acknowledged to be one of only three left in the city.

The Oak Room, Royal Oak.

Chapter Two

City Centre

15. GOLDEN LION, Church Street

The Golden Lion has a 300-year history that comfortably ensures its place amongst York's oldest surviving pubs. Although a property was known to have previously existed on the site Thomas Hessay leased the building in 1711 for a fee of £71 1s 6d. Hessay borrowed further money from Richard Booth, licensee of the Golden Fleece pub, and used the funds to open his own alehouse, adopting the sign of a golden lion.

Despite this earlier history the licence has only been traced to 1771 with Jonas Hill the landlord a year later. The pub was mentioned in the local press in 1773 as a 'well-known and accustomed inn' and contained adequate stabling, perhaps prompting Joseph Mollett, a Freeman of the City, to pay Ann Busfield the sum of £715 for the property. By 1779 the publican was Edward Turner while a decade later Matthew Braset was running the pub. Thomas Gowland was landlord by 1818 until the pub was auctioned a decade later. The auction was held in the Red Lion by Monk Bar and won by brothers Thomas and James Bell for £710, five pounds less than what Mollett had paid fifty years earlier.

In 1836 the southern section of Girdlergate was cleared and the road renamed Church Street. The redevelopment improved access to the Thursday Market and the pub would have benefitted from increased passing trade. In 1838 Mary and Robert Hick were in charge of the pub and were living with their six daughters and two sons. By 1848 Thomas Hastings was victualler. William Heslop took over in 1851 and remained in charge for a decade until passing on the licence to George Waterworth who would also remain in place for ten years.

In 1872 William Dent became licensee and his pub was known as the Golden Lion Spirit Vaults, perhaps suggesting it was renowned for the quality of its spirits as opposed to its ales. John Earle Wilkinson had taken over the pub by 1881 along with his wife Elizabeth and three children. In 1883 Wilkinson advertised for the safe return of his missing cat, which was noted as grey with white feet. He offered a ten shilling reward. The Wilkinsons remained in charge for seventeen years before John Vevers became landlord in 1898.

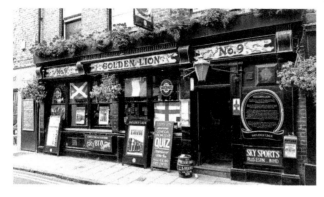

The Golden Lion.

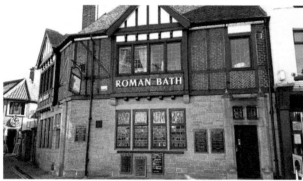

The Roman Bath.

By 1902 Vevers' pub still provided room for travellers although it only possessed one shared toilet, contained no stabling and was badly lit. Harry Humpherson took over in 1905 and shortly after that John William Hitchcock became landlord when it was referred to as Golden Lion Vaults in 1909. Joseph Ware was licensee in 1913 with John William Deacon landlord from at least 1919 until 1927.

In 1970 owners J. W. Cameron Brewery demolished the old pub and rebuilt a modern inn on the site, which reopened for business the following year. In a brazen attempt to mark the 1900-year anniversary of the city's founding in AD 71 the pub was renamed the 1900. It retained this unpopular name until 1983 when it reverted to its original title, the Golden Lion.

16. ROMAN BATH, St Sampson's Square

The Roman Bath in St Sampson's Square is situated above the remnants of an authentic *thermae,* a public bathing complex once prevalent throughout the Roman Empire. This extraordinary feature is probably the oldest extant part of any pub in the city and provides the Roman Bath pub with an unusual heritage.

The first record of a pub on this site is James Woodall's Barrel Churn which was trading in 1785, becoming the Cooper a few years later. In 1798 George Woodhall was landlord while by 1818 the pub was renamed the Barrel. All three names were linked to the brewing industry and suggest they were chosen with reference to a nearby brewhouse. By 1823 George Pennock had taken over and by 1828 the pub changed

name once more to the Coach and Horses. Pennock was a former mail coach driver and his business gradually became known as the Mail Coach in reference to his previous trade, first recorded as such in 1834. The pub became one of York's leading coaching inns and was used to serve market traders who conducted their business in front of the building. St Sampson's Square had traditionally been known as the Thursday Market and had been a bustling centre of commerce for hundreds of years.

Pennock retained control until sometime between 1857 and 1861 when the licence came into the possession of cabinet maker Philip Carlton. Pennock had been landlord for over thirty years. Carlton remained landlord for a further decade before George Milner took over the licence of the Mail Coach prior to 1872. By 1879 Milner had moved on to the Woolpack Inn in the Cattle Market and replaced by Robert Bean. In 1886 the licensee was Henry Preston and a year later Jane Wheatley. In 1889 the Rudd family took over the premises, with Londoner Henry William Rudd listed as victualler until his sister Emily Rudd took over following his death in 1902. The Rudds initially lived at the Mail Coach with their two young nieces Florence Rudd and Violet Ashthorpe and it seems Emily remained in place until the outbreak of the First World War.

After the war William Exelby Kendray took up the licence and remained in charge until the Second World War. The pub, which was still advertising good stabling as late as 1929, finally underwent a rebuilding programme in 1930 after a fire and was significantly altered. It was during work in the cellar that the breathtaking remains of the Roman bath were discovered, situated fifteen feet below modern street level. Subsequent archaeological investigation suggested the remains are around 1700 years old and part of the Roman fortress of Eboracum, the precursor of modern York. The largest section of the bath is the well-preserved, semi-circular *Caldarium*, essentially a hot steam room. The conspicuous series of pillars in the middle of the bath floor were part of the hypocaust, an innovative Roman method of underground heating. Tiles have also been unearthed bearing the inscriptions of the different Roman Legions which once occupied the city.

After the war the pub was recorded as being run by Minnie Kendray and she remained in charge until the 1960s. The pub was further refurbished in 1970 and renamed the Roman Bath when it reopened the following year, an attempt to capitalise on the pub's unique cellar. The bath is now a chargeable museum.

17. THREE CRANES, St Sampson's Square
The Three Cranes is prominently situated in the former Thursday Market area and has been trading since the mid-eighteenth century. The pub was run by Thomas Heckford in 1749 and would have been frequented by the market traders before, during and after the day's frenzied business. In 1785 the landlord was Richard Ambler and he remained in place until his death five years later.

Between 1818 and 1838 the pub was run by Robert Johnson until William Johnson took over the licence. By 1846 William Briggs had taken up residency and remained in charge for two decades. Briggs lived in the pub with his wife and children until his death in 1867. The Three Cranes changed ownership in 1872 when the landlord was George Scaife, another licensee who remained in charge for a lengthy period of time.

In December 1874 a man named Robert Halliday was found frozen to death in the snow having left the Three Cranes the previous night at 10pm in an 'advanced state of intoxication'.

By 1886 the pub had passed into the hands of former milkman Robert Thompson and he was listed as the primary licensee until 1902 when Christiana Elizabeth Thompson became landlady. In 1904 and 1910 the landlady ran afoul of the police when she was twice charged with allowing singing and dancing in an unlicensed room. On both occasions the charges were dismissed. Mrs Thompson remained in charge until her death in September 1916 whilst John Matchett served as landlord for a decade from 1921 until 1931.

The Three Cranes has retained its original purpose, serving as a respite for a local clientele in a traditional setting. Although a large, tiled mosaic on the exterior of the building grandly displays three cranes of the bird variety, the name is probably derived from the lifting cranes that were once situated in the yard behind the pub. Three Cranes Lane runs through the first floor of the pub to Swinegate, a route which historically provided access to and from the market before development of Church Street opened up the area.

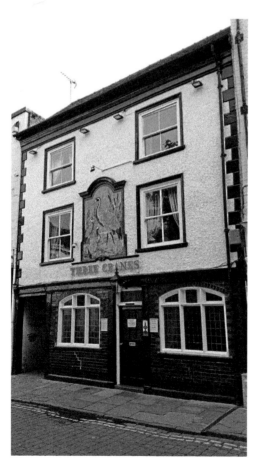

Three Cranes.

18. BURNS HOTEL, Market Street

The Burns Hotel can be traced to 1838 when a Scotsman William McLaren was the licensee of the Burns Coffee House, sometimes referred to as a hotel rather than a coffee house. It is possible he chose the name Burns in honour of his compatriot Robert Burns, the poet sometimes referred to as Scotland's favourite son.

The existence of a pub on this site can be linked to the development of Parliament Street which was opened in June 1836 to connect the city's two markets. This resulted in Jubbergate being divided into two sections either side of the new street, with the Burns Hotel standing on the southern side. By 1852 the decision was taken to widen this section and it was renamed Market Street, a decision that probably increased access and therefore trade to the pub. In 1854 McLaren advertised that he was letting out a 'new and commodious' room to be used solely for auctions. He died the following year and the hotel was taken over by his widow Sarah who retained control until her own death in August 1879. It was known that the Burns had its own brewery and it seems probable they produced their own product onsite.

After the lengthy tenure of the McLarens the hotel went through a number of landlords in short succession, with John Garth in charge by 1885, Robert Dunmore by

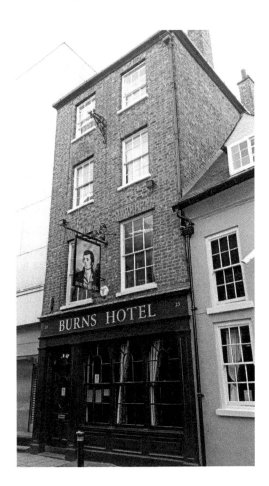

Burns Hotel.

1893 and Joseph Booth by 1895 when it was known as the Burns Inn. Paul Eastwood took over in 1898 and within two years Joseph Blackburn was the licensee. By 1902 the four-storeyed hotel, in addition to possessing the customary taproom and bar, provided two of its six bedrooms to travellers.

Although the second and third floors still retain their original nineteenth-century layout, the ground floor was altered during rebuilding work in 1975 when a new frontage was added to the pub. The Grade II listed pub reopened under the name Hansom Cab in honour of York native Joseph Aloysius Hansom, an architect best remembered for his invention of the eponymous horse-drawn carriage. The Burns Hotel name was reinstated in 2013 with a new pub sign featuring the portrait of the acclaimed Scottish poet.

19. KINGS ARMS, King's Staith

The Kings Arms pub is located on the edge of the River Ouse and has become nationally renowned in recent times for its propensity to flood when the river rises. The early seventeenth century building was constructed on the King's Staith, traditionally the site of the city's oldest and busiest quay, and has traded as a public house since at least 1783 under landlord James Anderson.

Prior to this it seems likely the timber and stone building was used as a customs house connected with the bustling trade along the riverfront. Three streets connected King's Staith with Castlegate and were known as Water Lanes. The three poverty-ridden passageways were notoriously crowded and known for high rates of crime and prostitution. In 1818 the landlord of the Kings Arms on First Water Lane was Richard Fisher although it is unclear whether this is the same pub as the present Kings Arms.

In 1828 the publican of the Kings Arms of King's Staith was Benjamin Thompson while by 1849 John Smith was in charge of the riverside pub. In 1851 Henry Crowther took over the pub with his wife Susannah and remained in charge for at least a decade. In January 1855 the landlord was charged with allowing persons of notorious character to fraternise in his pub and was fined 5 shillings for his breach of the law, perhaps an indication of the clientele that frequented the inn at this time.

By 1867 new licensee George Duckitt changed the name of his tavern to the Ouse Bridge Inn, a name it would retain for over a century. A number of landlords took over the Ouse Bridge Inn including Thomas Wray, John Birch, J. P. Dawson and John Cussans until Joseph Booth took over just before the end of the century. By 1902 Booth was living in the crowded inn with his wife Mary and adult children George and Emma. While George worked as a cabinet maker it seems Emma helped out in the pub, working as the barmaid. It is known the inn at this time had a club room upstairs along with three bedrooms for the family whilst on the ground floor was a taproom, a smoke room and a dram shop. Due to the small nature of the building each room was presumably limited in capacity.

After the pub reverted to the Kings Arms name in March 1974 the pub signs were updated to display the image and coat of arms of Richard III, the notorious monarch with a number of links to Yorkshire. Due to the constant threat of flooding the original doorway which opened onto the quay was moved to the rear side of the building at

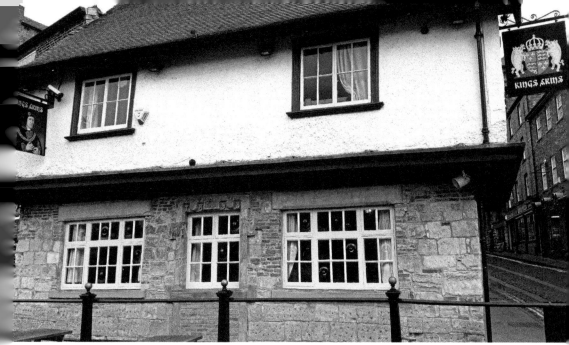

Above: The Kings Arms.

Right: Original doorway, The Kings Arms.

Old Ouse Tavern window, Kings Arms.

some point prior to 1853 in order to allow access in the event of flooding. The interior has been kept understandably threadbare with the original supporting timber beams and stone slab floors betraying the inn's lengthy heritage. At the rear of the pub where the former smoke room was once based are a collection of engraved windows which display the Ouse Bridge Inn name.

20. BLUE BOAR, Castlegate

The Blue Boar has traded on the same site in Castlegate under a variety of names since the early eighteenth century. The current building was erected on the site in 1730 to fulfil the growing need for coaching inns in York and replaced an extant pub known as the Robin Hood, run by landlord Christopher Blanchard.

The three-storeyed inn's licensee in 1788 was William Cartwright and in 1795 it was known as the Robin Hood and Little John Inn. Shortly thereafter the inn was once again trading solely as the Robin Hood. By 1803 the landlord was John Cartwright who in August 1808 took out an advert in the local press to appease fears he was about to leave the Robin Hood pub. Nonetheless by February 1809 he resigned his position. Cartwright was replaced by John Clayton who took out an advertisement to publicise his new tenancy and to declare his intention to secure the 'best wines, spirits and any other requisite' while noting the proximity between the Robin Hood and the castle was convenient for Gentlemen of the Law wishing to parch their thirst.

A meeting took place at Clayton's inn in 1816 between a group of unhappy innkeepers who were declaring their continued unease at the billeting of soldiers in their buildings, as was the custom in a period before barracks became commonplace. By the early

nineteenth century the Robin Hood was considered to be a busy commercial hotel and was frequented by a series of carriers and coaches. The Providence coach was noted to leave the inn at 6.45 a.m. on a daily basis bound for Selby. In July 1819 the Caledonia Steam Packet company announced the establishment of a new coach called Diligence to run from the Robin Hood pub to Selby every Monday, Wednesday and Friday.

After John Clayton's death his widow Frances continued to run the Robin Hood and in 1824 advertised improvements to her inn that would result in better accommodation and comfort to her patrons. In November 1828 she announced she was leaving the inn and transferring the licence to William Maude, formerly of the Commercial Coffee House on Ousegate. In 1838 the inn became newsworthy when licensee John J. Anderson was declared bankrupt with debts amounting to £2,500. He would eventually be imprisoned for six months due his failure to settle the sum.

In 1843 the licensee was Daniel Addison who remained at the Robin Hood for over a decade. He was replaced by George Osborn while in 1872 the landlord was Robert Dempsey, followed by John George Dawson. Although Castlegate is today a narrow backstreet it had once been the main thoroughfare for traffic to and from York Castle. The passing trade would have greatly benefited the Robin Hood and this remained the case until Clifford Street was built in 1881.

Thomas Todd and Ralph Johnson served as landlords until 1893 when John Abell took over. He renamed the inn the Little John and conceived a catchy couplet to advertise this name change – 'Robin Hood is dead and gone, now come and drink with Little John'.

In 2012 the inn was reopened after a period of closure as the Blue Boar, a reference to another inn of that name which had once stood on Castlegate. It was in the original Blue Boar pub that the body of notorious highwayman Dick Turpin was displayed after he was hanged at York's Tyburn in 1739. The original Blue Boar closed down in 1775.

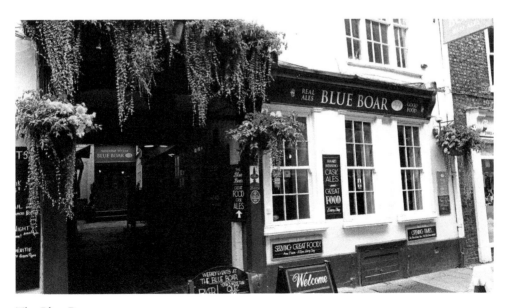

The Blue Boar.

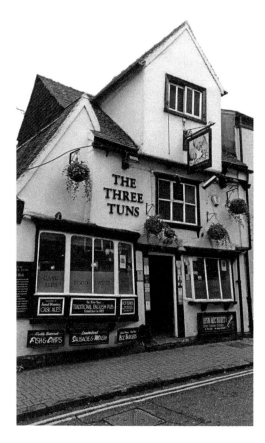

The Three Tuns.

21. THE THREE TUNS, Coppergate

The Three Tuns on Coppergate is noteworthy for its unusual and slightly uneven exterior, a haphazard design that serves as a clear indicator of the pub's lengthy existence. A pub was first mentioned on the site in 1782 under landlord Thomas Spink and it is thought it originally traded under the Three Tuns name, possibly derived from the coat of arms of the Company of Vinters which featured three large barrels amongst other imagery.

By 1830 the business was trading as the Yorkshireman Coffee House although it gradually became simply known as the Yorkshireman. In 1843 the landlady was Hannah Penrose until her death in 1848 when the licence was taken over by Mrs Atkinson. Later that year Atkinson was warned by city officials and threatened with closure if she didn't maintain a more reputable premises, indicative that the Yorkshireman attracted a rowdy clientele.

By 1851 the landlady of the Yorkshireman was Barbara Dawson of Helmsley. The widowed Dawson lived in the pub with her children Arthur and John as well as her elderly mother and her brother Robert, a Chelsea Pensioner. In 1867 the landlady was Fanny Warneford, a widow who had previously run the nearby Golden Fleece,

while by 1872 David Rennison was in charge of the inn. In 1874 Rennison was the victim of two separate crimes; in July a man was arrested after being found on a roof in the yard and was accused of burglary. Although no items were found on his person he was nonetheless jailed for one month hard labour for being a vagabond and a rogue. In September another man was jailed for two months hard labour for stealing 2s 6d from Rennison's till after trying to get free drinks from other customers.

In 1876 John Dove took over the inn until his death three years later when his widow Ann continued on her own. Joseph Booth and John Berry took over in short succession until in 1891 Jabez Walker moved into the Yorkshireman with his wife Sarah and their two children. In 1888 another crime was committed at the inn when William Plews was arrested for stealing a cashbox containing over three pounds.

In 1898 the pub was taken over by John Henry Jarratt and coincided with Thackeray's Brewery relocating their central office to the pub. In 1909 Raimes Dalton became landlord of the Yorkshireman and ran the inn until his death in December 1930. During renovation work in the twentieth century a considerable hoard of gold was found in one of the wooden beams with coins thought to date from the reign of Charles I. It has been theorised that the coins were possibly placed there by a soldier during the English Civil War. The failure to collect them suggests the soldier or person who placed the coins in the beam didn't survive to return. The pub was renamed the Three Tuns in 1930.

22. GOLDEN FLEECE, Pavement

The Golden Fleece on Pavement is regarded as one of York's oldest drinking venues with a licence traced to at least 1668, second only to Ye Olde Starre Inne. Although the building can be traced to 1503 the earliest mention of a pub on this site was in 1666 when landlord Richard Booth was authorised to produce a number of trade tokens after the English Civil War resulting in a shortage of currency.

During the reign of Henry VIII the land was owned by the Company of Merchant Adventurers who were based in an opulent hall on nearby Fossgate. These merchants were heavily involved in the wool trade and operated in the Wool Market area only a short distance from where the pub stands. It is probable that this connection influenced the name of the pub which is often represented by a large sheep. In 1557 the company sold the house to the Herbert family whilst by 1702 the property was owned by John Peckett, a wealthy merchant and Lord Mayor of York.

The adjoining twin-gabled building is now known as Thomas Herbert House after its one-time inhabitant and is regarded as one of the largest medieval townhouses still in existence. The house originally possessed a third gable which was situated above the present inn, which it obscured. Traditionally the Golden Fleece was therefore only accessible via a lengthy passageway and not from the street as it is today, an architectural feature still evident from the brick archway on the façade of the pub.

In 1733 the name was recorded as the Fleece, a name it's still informally referred to as today. The landlord in 1787 was Christopher Smithies while by 1794 William Clark

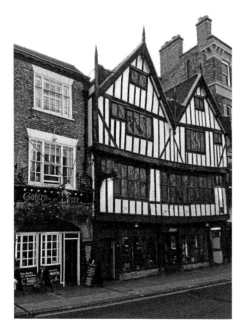

Golden Fleece and Thomas Herbert House.

The Golden Fleece sign.

was listed as publican. By 1818 Thomas Bell was licensee while ten years later William Schofield was in charge. By 1830 Matthew Todd was landlord for a short period until 1832 when the inn was advertised to let. It was described as 'old-established and well-accustomed' and was enough to attract Thomas Triffitt to take over the premises. After his death in 1835 aged forty his widow Elizabeth became landlady. She received a level of local media attention in November 1833 for an incident that highlighted her integrity and honesty. A gentleman had visited her pub one night and mentioned he was travelling to Hull the following morning by coach. While locking up the pub Elizabeth found a ten pound note and came to the conclusion that it belonged to the gentleman. The following morning Mrs Triffitt flagged down the stagecoach as it passed her pub and reunited the traveller with his money, an act which earned her the respect of those present.

By 1849 Elizabeth Young was running the Fleece alongside her adult son William and four employees. She retained control for almost a decade until Edward Warneford became landlord. Warneford moved into the Fleece with his wife Fanny and young children Henry, Edward, Fanny and Frederick. Edward Warneford died in March 1864 and the pub was briefly in the hands of Joseph Beaumont until William Coates took up the licence in 1871. Edward's widow Fanny Warneford meanwhile took up residence in the nearby Yorkshireman Inn.

William Coates was landlord of the Fleece Inn for over a decade and advertised his pub as offering 'excellent accommodation for visitors' in addition to supplying 'well-aired beds'. He remained in control until his death in 1882 when his widow Helen Coates continued operating the business. Mrs Coates was landlady on her own for ten years until she remarried to George Daniel, who took over the licence. Helen Coates/Daniel passed away in April 1899 aged sixty-six. Her widower George continued to run his wife's pub and in 1902 the property was considered to be a very old building but still spacious, possessing ten bedrooms in total with five available for travellers. In 1905 Frederick Coates took over from George Daniel. During the First World War the Fleece was regularly frequented by soldiers stationed in the city and in 1915 the landlord Frederick Jackson was fined for allowing soldiers to drink outside permitted hours.

Today the Golden Fleece is regarded as one of England's most haunted spots. A famous ghost is said to be Geoff Monroe, a Canadian airman who was staying in the pub during the Second World War. Monroe fell from a bedroom window to his death and has been said to haunt the Golden Fleece ever since, appearing before startled guests in his uniform. Other paranormal activity is said to include bedclothes being disrupted and the sound of footsteps running through passageways. Other sightings include a man named One-Eyed Jack and a Victorian boy who was trampled to death by horses. Furthermore the Fleece was occasionally used to temporarily house convicted prisoners on the way to court to be sentenced. Some of the corpses of those prisoners who were hanged would be stored in the inn's cellar until they were collected by family members, another gruesome aspect of the inn's past. A noticeable interior feature of the Fleece is the sloping corridor, considered to be a result of the pub's lack of foundations.

The dining room, Golden Fleece.

23. THE BLUE BELL, Fossgate

The Blue Bell is a fascinating little pub situated on Fossgate which has seen minimal alteration over the last century. The intimate interior of the Blue Bell is therefore often considered to be of significant historical interest which has earned the pub a well-regarded reputation.

A pub was known to be trading on this site as early as 1798 and was one of two Blue Bells operating in the area, the other situated nearer Walmgate. In 1818 the landlord of the Blue Bell was Isaac Wilson while by 1829 Joseph Powell had taken over, remaining in charge for at least fifteen years. By 1849 Joseph Hall was landlord and managed the pub until 1861, living in the building with his wife Mary and children William, Thomas, Sarah and Charles. He died in 1864 aged fifty-two and was replaced briefly by John Tanfield until Frances Maxwell became landlady in 1872.

Within a few years Sarah Brown was the licensee and remained at the Blue Bell for a decade. Sarah was widowed and lived at the pub with her eldest daughter Lucy and son-in-law George, who in 1881 had an infant child. Her other children William and Sarah also lived on the premises. Mary Ann Woods became the third consecutive female publican when she replaced Sarah Brown and lived at the Blue Bell until around 1893 when she was replaced by David Noonan, an Irishman from Cork who moved into the pub with his wife and two children.

By 1902 the Blue Bell was regarded as a very poor house and not considered fit for purpose. At the time the pub had a bar and a taproom that were not kept in a good state and the Blue Bell was threatened with closure in 1903, due not only to the dilapidated state of the building but also the proliferation of drinking establishments in the area.

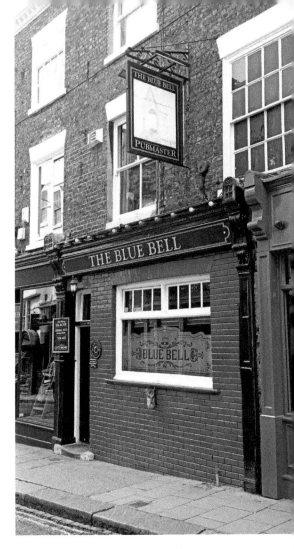

Right: The Blue Bell.

Below: Smoke Room, The Blue Bell.

Serving hatch, The Blue Bell.

The landlord at this time was Harry Hayes, who in January 1903 was taken to court accused of selling alcohol to someone in an inebriated state. Although acquitted of this charge, a month later he was back in court charged with being intoxicated in his own pub and non-payment of his rent. Hayes was duly sacked from his job. His replacement was George Edwin Robinson and it seems he succeeded in convincing the authorities to renew the pub's licence, which was granted in March that year.

Robinson remained in control of the Blue Bell through two World Wars until his death in 1948 when the licence passed to his widow Annie. Robinson had played an active role in the community and was recognised as one of the first directors of York City Football Club, hosting occasional club meetings at his pub. After Annie Robinson died in 1963 the Blue Bell remained in the family when her daughter Edith Pinder took over the licence. Edith remained landlady until her retirement in 1992 when the pub left the Robinson family after eighty-nine years of service. This continuous ownership played a vital role in the pub avoiding intermittent modernisation by new owners and as a result the pub has retained its Edwardian character.

The compact interior of the Blue Bell is considerably smaller than other local pubs and only consists of a square bar room in the front of the pub and the former smoke room towards the rear. An intriguing feature which survives from the Edwardian renovation is the two small serving hatches, one in the smoke room and one in the lobby alcove which connects both rooms. Also visible is the embossed glass on various doors and the abundance of original wood panelling. The exterior of the Blue Bell features distinctive Victorian-style glazed red brickwork which compliments the engraved main window bearing the pub name.

Edwardian wooden benches, The Blue Bell.

24. BLACK SWAN, Peasholme Green

The Black Swan Inn on Peasholme Green is arguably the most well known of York's historic pubs, a reputation it owes to a rich heritage stretching over 600 years. The charming black and white timber-framed building is first thought to have been erected during the early fifteenth century and further extended during the late sixteenth and early seventeenth centuries. A sensitive renovation in the early twentieth century has ensured this medieval townhouse turned public house still serves the city's twenty-first century inhabitants.

The building's origins can be traced to the prominent Bowes family who were a significant presence in York during the medieval period. William Bowes served as Sheriff of York in 1402 before becoming Lord Mayor in 1417 and 1428. His son, also William, served as MP for York whilst his great-grandson Sir Martin Bowes flourished under the Tudors. Sir Martin was a goldsmith who made a fortune trading in London and advanced to become the city's Lord Mayor in 1545 under Henry VIII. He was later appointed sub-treasurer of the Royal Mint and gained further prestige as jeweller to Elizabeth I.

Despite his success in London it appears Sir Martin never forgot his York roots and invested some of his wealth in property in his hometown, particularly enlarging his ancestral home on Peasholme Green. The core of the Black Swan pub today can be traced to work undertaken by Bowes. The Bowes were gradually replaced in Peasholme Green by the Thompson family, another local dynasty who were influential in the political scene of York.

Edward Thompson served as Lord Mayor of York in 1683 and was also a notable wine merchant with a business portfolio that include the Star Inn on Stonegate. His

daughter Henrietta was probably born in the townhouse and through her marriage to Edward Wolfe was mother of British Army General James Wolfe. The general won a great military victory over the French in Quebec and became a national hero during the eighteenth century; a local myth often states that Wolfe was born in the Thompson family home in York but his birth actually occurred in Kent in January 1727. Nonetheless his parents left York the previous year and it's tantalising to suggest this British hero may have been conceived in the building now known as the Black Swan.

In 1710 the building became acquainted with the pub trade when the Innholders Company held a social gathering in the house after a court meeting across the road at St Anthony's Hall. By 1787 the house was first mentioned as a pub when records refer to the building as the Swan. In November 1808 the pub was mentioned in local press when it was reported that a lady named Mrs Weston had given birth to a son in the Black Swan. The birth was newsworthy as the mother often exhibited in the city as an 'extraordinary diminutive of the human species, though without deformity, being but 34 inches high'.

In 1818 the pub was run by thirty-four-year-old Thomas Brabiner and his wife Sarah. The Black Swan at this time stood on the periphery of Haymarket, a bustling part of the city frequented by farm traders, and it seems likely that the pub benefited from the

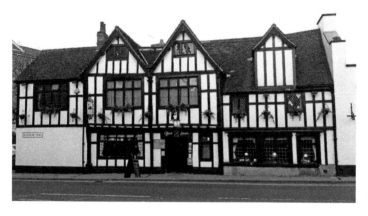

Black Swan.

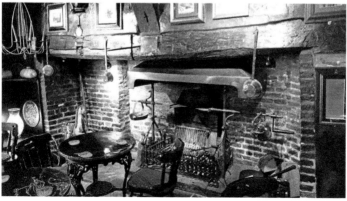

Bar room fireplace, Black Swan.

activity in the area. By 1828 Sarah Brabiner was in sole charge of the pub after the death of her husband while in June 1839 the Black Swan was announced as the venue for a new lodge of ancient druids.

By 1843 the landlord was William Atkinson followed by his daughter Ann and son-in-law John Barnett in 1851 who had been married a year earlier. By 1858 Ann Barnett was in sole charge of the pub after the death of her husband. In 1867 the publican was John Taylor while by 1876 William Briggs had taken over the Black Swan. Briggs was thirty-one years old and moved into the pub with his wife Elizabeth, teenage step-children Jessie and Charles Taylor and his one-year-old twins John and Jacob.

In December 1881 the pub was advertised as possessing a 'good 3-stalled stable with hayloft' while Briggs also used the local press to regularly advertise public auctions he hosted at the Black Swan. A later landlord Edgar Henry used to regale his customers with a tale about a local bricklayer who sold his wife in 1884 for the sum of 1d 6s which was supposedly negotiated over a pint of ale. In April 1887 Briggs placed an advert for the recruitment of a blacksmith and a year later was looking for an apprentice to join his burgeoning business.

Briggs remained in charge of the Black Swan until his death aged forty-seven on 20 November 1892 when his wife Elizabeth took over the licence. It can be assumed that William Briggs was loved by his family for they took out an advert in the local press on the one year anniversary of his passing declaring he was 'gone, but not forgotten'.

Within three years the licence had transferred to Edward Percy Smith, the husband of Elizabeth's daughter Jessie. Elizabeth Briggs continued to live at the Black Swan and was known to trade as a shoeing smith, an industry her family had long been involved in and particularly convenient at an inn with an abundance of stabling. During their tenure as licensees Edward and Jessie Smith had three children, Elizabeth, John William and Doris. In 1897 the Black Swan was considered to be a spacious house while in 1902 it was recorded that the inn had five bedrooms, enough accommodation for twelve travellers and capable of providing stabling for twenty horses. Jacob Briggs had also returned to his childhood home with his daughter Gladys and was trading as a blacksmith from the property. In 1900 Edward Smith was mentioned in the local press when he presented a Private M. Fletcher with a silver mounted pipe and engraved silver shield as a mark of respect for the soldier's enlistment in the army for the Boer War.

By 1913 the Black Swan's publican was Fred Wright which brought to an end the Briggs family's thirty-year involvement in the pub. In 1930 the inn was remodelled by owners Tadcaster Tower Brewery who removed large sections of the stucco plastering and exposed the original timbers that have since become a trademark of the inn. During the Second World War the pub was utilised as a horse refuge due to its substantial stabling while there was a further overhaul in 1967.

Notable structural features of the Black Swan include the heavy oak door that is understood to be at least a few hundred years old, complete with original peephole. There was originally a second doorway which suggests the building was for a period divided into two separate sections before it was amalgamated into one complex. On the ground floor the pub is divided into three rooms with a stone-flagged entrance passage connecting each chamber. The front left room possesses an intriguing collection of

reset seventeenth-century panelling while the rear left bar room contains an abundance of wooden beams built around a sizable fireplace which was presumably once used for cooking.

The creaking and uneven seventeenth-century spiral staircase leads to a large function room designed in the *Trompe-l'oeil*, or 'deceive the eye', style. Upon first impression the wooden panelling appears raised but upon closer inspection is revealed to be a painted illusion. The Thompson family had a connection with the nearby St Cuthbert's Church and for many years it was believed there was an underground passage leading from the premises to the church. In 2003 during renovations workmen found a red brick tunnel leading in the direction of the church, perhaps validating the rumours about the passage.

The twin-gabled façade and jettied first floor suggests the building in its current form dates from the Elizabethan period. The gables have bargeboards with elaborate designs displaying various imagery. The two-storeyed building on the right was a nineteenth-century extension while the left section is also a relatively new erection that replaced a brick structure which had comprised two separate dwellings.

The Black Swan allegedly has a collection of ghosts which dwell within the inn, notably a young lady in a long white dress and dark hair who stands staring absent-mindedly into the fireplace. Another ghost is said to take the form of a well-dressed Victorian gentleman in a bowler hat impatiently checking his pocket watch as though he is awaiting the arrival of somebody before fading away. The Black Swan is Grade II listed and considered a CAMRA Heritage pub.

Stone corridor, Black Swan.

Right: Seventeenth-century staircase, Black Swan.

Below: *Trompe-l'oeil* panelling in the Wolfe Room, Black Swan.

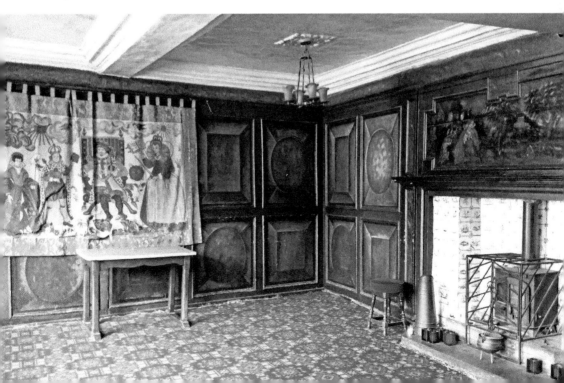

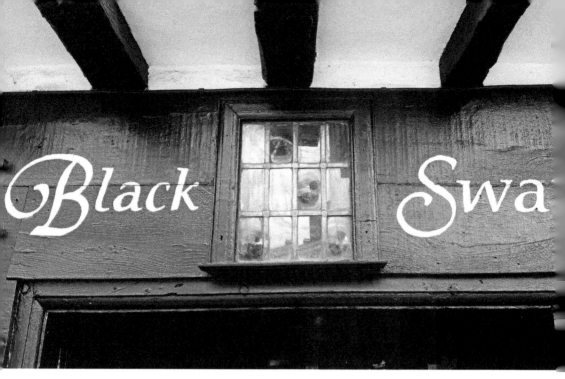

Black Swan door sign.

Chapter Three

Micklegate Quarter

25. BAY HORSE, Blossom Street

The Bay Horse has been trading as a pub for over 250 years and has long been a popular venue on the periphery of the inner city. Although it is possible the pub had existed for longer, particularly as the building has evidence of seventeenth-century origins, the first record of a public house on this site is in 1748. The name is thought to originate from a racehorse belonging to Lord Rockingham called Bay Malton. The champion stallion won a number of races, amongst them a meeting at York Racecourse in August 1766.

The landlord by 1828 was John Shepherd and he retained control of the Bay Horse until at least 1837. By 1843 Henry Herbard was the publican, followed by Joseph Atkinson in 1849, Joseph Hardcastle in 1849 and John Lupton in 1858. By 1861 Richard Cowper and his wife Eliza were listed as the licensees while the following year the premises and its adjoining brewhouse were bought by the Institute of the Blessed Virgin Mary, a religious convent which had a significant presence in the area. They remained the owners until 1874. Cowper was a noted horse breaker and advertised his services in the local papers.

Cowper was replaced by George Benson prior to 1867 and remained the licensee until 1885. Benson's wife Mary died in 1879 which left George the unenviable task of raising their children and running the pub. Robert Kent took over from Benson and was in charge until 1893. Thomas Harrison was landlord for two years until Francis Walter Dixon took over for a couple of years until his death in 1897, aged only thirty-two. Dixon's widow Harriet kept the Bay Horse and was landlady for a further decade, simultaneously raising her young family. In 1901 she was only aged twenty-eight while she had four children aged between four and ten.

Despite the pressures of motherhood and running a business by 1902 the pub was considered to be kept in a clean state and was recorded as possessing a sitting room, two smoke rooms, a club room and a bar. The Bay Horse was restored by John Smith Brewery's architects in 1969 with some of the pub's original fittings reused. The result is a charming and somewhat authentic Victorian-era interior.

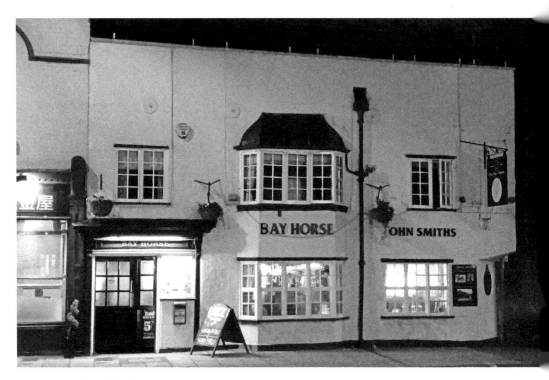

Above: The Bay Horse.

Below: Front room, Bay Horse.

26. WINDMILL INN, Blossom Street

The Windmill has traded in its current location on the northern corner of Blossom Street since the later part of the eighteenth century, with records confirming its existence since at least 1769. This part of the city has been an important thoroughfare since the medieval period, with the nearby Micklegate Bar considered the traditional entrance to York for visiting monarchs. The area's activity would have considerably increased after the railway came to York, particularly when a new station was opened on land behind the Windmill in 1877.

The Windmill Inn was recorded as being run by Joseph Rose in 1798 while by 1818 it was in the hands of William Crummack, who ran the inn for over a quarter of a century until his death in 1847. His widow Martha took over after her husband's death until she passed away aged seventy-four in 1854. A plaque is commemorated to their memory in Holy Trinity Church on Micklegate, a symbol of their relative importance and success in the parish.

William Hunter took over the Windmill after the Crummacks while by 1867 John Wade Bateman was the landlord. Bateman remained in charge for almost a decade until the hotel was advertised for let, promoted as one of the oldest established public houses in the city and in 'first-class working order'. The advert stressed the Windmill's capability of providing enough stabling for sixty-five horses and was valued at £800.

Within a year James Mason was in charge of the hotel whilst by 1881 Henry Hudson was the proprietor. Edwin Henry Cooper took over in 1889. The inn was deemed sufficiently attractive to be the subject of a costly takeover in the last decade of the nineteenth century when in July 1893 E. P. Brett paid £3,750 for the Windmill and

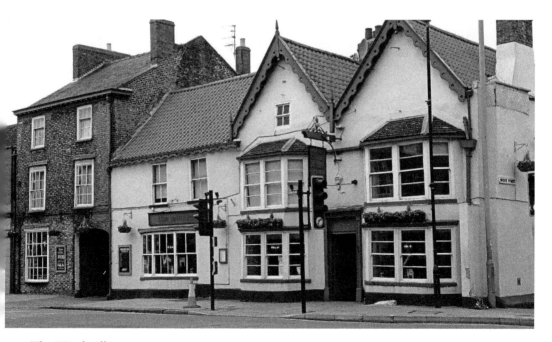

The Windmill.

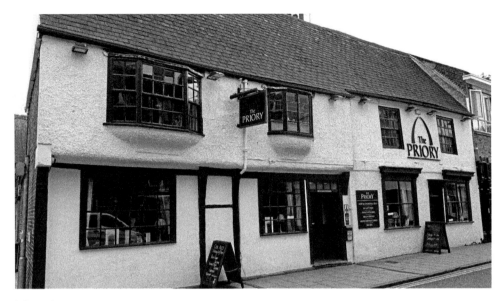

The Priory.

its adjoining brewhouse, appointing Charles George Harper as landlord in 1896. The large sum may have been related to the inn's ability to cater to a large number of guests, a profitable enterprise for the owners. By 1902 it was recorded the complex contained twenty-one bedrooms in total with as many as sixteen set aside for travellers. This was in addition to standard features such as a bar, a taproom, a coffee room and a dining room. By 1906 the Windmill, long considered a traditional coaching inn, started to cater to more modern forms of transport. An advertising board upon the inn's façade publicised the property's ability to provide accommodation to motor cars and cyclists.

Although it presently inhabits the corner of Blossom Street and Queen Street this has only been the case since 1911 when the neighbouring building was demolished to widen the junction and ease traffic congestion. It has been rumoured that the Windmill is haunted by the ghost of a young girl who was run over and killed by a brewer's cart whilst there have been reports of an icy cold mist appearing inside the building. Further paranormal activity such as eerie footsteps and shattered glasses have also been reported.

27. THE PRIORY, Micklegate

The Priory stands on Micklegate a short walk from the historic bar and has been trading for around 200 years. In 1818 it was recorded the pub was known as the Coach and Horses under licensee Joseph Coultas, a name it would retain until the end of the twentieth century.

By 1830 the publican was Jeremiah Coultas with John Bewley taking over the licence in 1838. In 1843 Bewley advertised his pub for let, describing it as 'old established and well-accustomed'. By 1846 John Carr was landlord followed by James Cullum in 1849 and Robert Stewart in 1858. The Stewart family were originally from Durham and

comprised Robert's wife Eleanor, their adult son Joseph and youngest child George. They had a number of other teenage and adult children who were living away from the pub at the time. After Robert's death his widow Eleanor took over the licence and managed the Coach and Horses for another seventeen years.

The Coach and Horses played a key role in matters pertaining to enginemen and those employed by the railways during the nineteenth century. In March 1867 union delegates representing almost 1000 enginemen used the pub as a base to discuss strike action whilst in May 1875 the National Federation of Enginemen's Protection Associations held their annual conference at Eleanor Stewart's pub. York's signalmen also met at the Coach and Horses in December 1892 to discuss their working hours and pay.

By 1881 it seems the seventy-five-year old Eleanor was running the Coach and Horses on her own although her engine fitter son James was still living on site. Eleanor died in 1887 and by 1889 George Vincent was in control of the licence. Vincent lived with his wife Mary, eldest daughter Louisa and twin daughters Jane and Mary. After George's death his licence was taken over by his widow, who was in charge by 1896. In 1902 under Mary's tenure the pub possessed a bar-parlour, a taproom and a serving bar. It was reported in the Chief Constable's report that the urinal was unsatisfactory and unsanitary. In order to retain its licence a permanent urinal was required rather than the temporary toilet which was situated down a narrow passage. It seems this was complied with as the pub continued to trade after the inspection.

The pub was bought by Tetley's Brewery at an auction in 1945 and a year later they purchased the adjoining building, into which the pub eventually expanded. While the pub was often informally known as the Little Coach or simply the Coach, in October 1996 the name was changed to the Phalanx and Firkin. In March 2003 the pub was renamed the Priory, a reference to an archway of the Trinity Priory which stood in the vicinity prior to 1854.

28. FALCON TAP, Micklegate

The Falcon Tap is one of the city's longest running pubs and has been operating under various names since the early eighteenth century. As early as 1736 local historian Francis Drake described the Falcon as one of two inns of 'good resort' in the area. In 1818 newspaper proprietor and antiquarian William Hargrove went further and described the pub as 'a very excellent inn' and the 'only one of consequence in this street'. Hargrove considered the accommodation to be very good with the stables and outbuildings extending to Toft Green in the rear.

In 1743 the licensee was Joseph Anderea and the pub was auctioned in November that year. In April 1756 it was recorded that Lt-Col. Bucks had five of his soldiers billeted at the pub under landlord John Shepherd. George Smithson was publican from 1765 to 1798, his thirty-three years in charge the longest tenure in the pub's history. By 1818 the landlady was Elizabeth Richardson with John Seller the licensee by 1827. Seller remained at the Falcon Inn for a decade and was replaced by George Britton prior to 1838, who Sellar 'confidently recommended as his successor'. The pub was demolished in 1842 because of its age and was rebuilt the following year.

The Falcon didn't reopen until 1850 when new landlord Thomas Walker announced that the inn had been 'rebuilt and newly refurbished'.

By 1858 the landlord was James Harrison, followed by William Teasdale in 1861, William Foster in 1867 and Charles Hurst in 1872. William Smith was landlord in 1876 before being replaced by Charles Jewitt in 1880. Jewitt was the son-in-law of Eleanor Stewart, landlady of the Coach and Horses on Mickelgate, and moved into the Falcon with her daughter Jane and their son Robert. The Jewitts proprietorship of the Falcon coincided with the addition of a large wooden falcon to the pub's frontage, a feature which has become synonymous with the pub over the last century.

By 1889 Tom Johnson was the Falcon's landlord followed in 1893 by Palliser Addyman. In 1900 Joseph Ellis took over briefly followed by his widow Martha. In 1902 the Falcon Inn was considered to be a suitable business, in contrast to a large number of pubs in the city which the authorities considered to be kept in poor conditions. All five bedrooms were occupied by the Ellis family, which included Martha plus six daughters and one son. A billiard room upstairs was made available for customers while on the ground floor there was a smoke room and a dram shop.

The lengthy history of the Falcon Inn appeared to have come to an end in 2002 when the pub was refurbished and reopened as Rumours, a 1980s theme pub. In 2014 the premises changed ownership and was once again renovated, reopening as the Falcon Tap with a traditional interior more suited to the pub's history.

29. THE ACKHORNE, St Martin's Lane

The Ackhorne is situated in a narrow alleyway between Micklegate and Fetter Lane, an atmospheric approach to a pub that has traded on the site for over 200 years. St Martin's Lane runs adjacent to the church from which it derives its name and it was on this land that John Taylor owned a substantial house and courtyard in the late eighteenth century. In 1783 the premises was purchased by John Hill, a publican who owned the Golden Ball in the nearby Fetter Lane, and he gradually converted the house into a pub. The new establishment was given a sign depicting an acorn.

By 1818 the landlord was John Holliday and the inn was formally recorded as the Acorn. Holliday was followed by William Hickton prior to 1828 and James Simpson by 1838. In 1843 the licensee was Isaac Mortimer who remained in charge for the remainder of the decade. In 1851 William Snow became landlord, succeeded by William Robinson in 1858 and William Webster in 1867. Webster and his wife Ann remained in charge of the Acorn for over a decade until Charles Henry Jones became landlord in 1879.

By 1881 John Hill was recorded as the licensee followed by William Henry Wales in 1885 and Arthur Robshaw in 1889. Thomas James Standidge was licensee in 1895 followed by Joseph Hewson a year later. The high turnover of landlords throughout the nineteenth century suggests that business was unstable and incapable of attracting a publican to stay for any considerable amount of time. By 1902 Hewson's pub contained three bedrooms which were reserved for the use of his family with a smoke room and dram shop for the customers. He was replaced by George Hopwood in 1905.

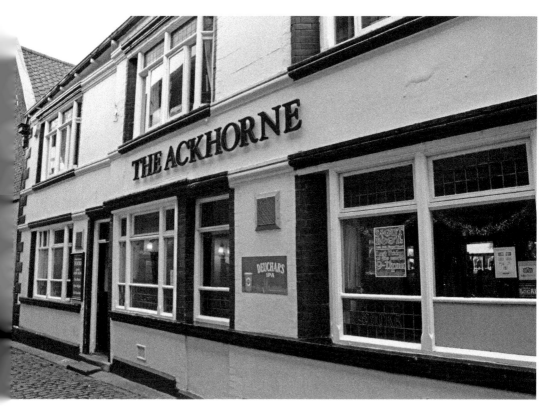

Above: The Ackhorne.

Below: Bar room, The Ackhorne.

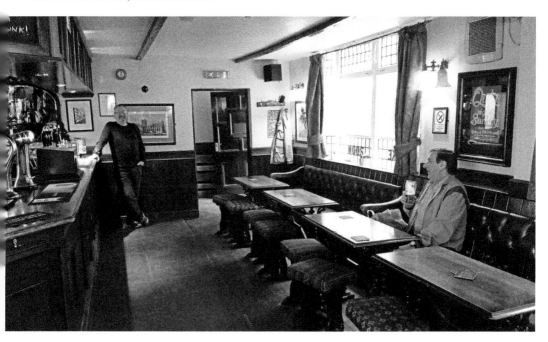

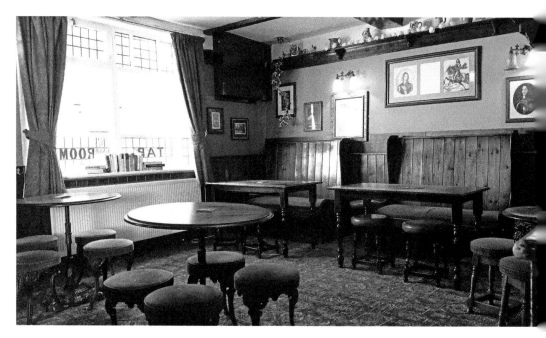

Tap Room, The Ackhorne.

The Ackhorne's interior is still largely intact from the early twentieth century, with substantial wood panelling and stained glass windows depicting the erstwhile names of the two remaining rooms. Following refurbishment work in 1993 the pub reverted to its original name of the Ackhorne.

30. MALTINGS, Tanner's Moat

The Maltings is one of York's most distinctive pubs, due in part to a prominent position alongside Lendal Bridge and a peculiar if popular black frontage that conceals a building of substantial heritage. Tanner's Moat and the immediate area played an integral role in York's transport history as it was situated in close proximity to both the River Ouse and the city's railway station which opened in nearby Toft Green in June 1841.

The increased level of activity in the area proved to be an ideal business opportunity and a public house was opened on the current site of the Maltings in 1842. The pub was predictably named the Railway Tavern and was popular with both workers and travellers. An early landlord was Joseph Spencer who was in charge by 1848 while Richard Horner had taken over the premises by 1858. John Mintoff was publican in 1867 followed by Charles Precious by 1872.

The opening of a new bridge crossing the river initially increased trade in the area although this would be tempered somewhat when the railway station was relocated outside the walls to its present site in 1877. The landlord during this time period was Francis Dalton. The pub continued to trade as the Railway Tavern until 1885 when the name was changed to the more pertinent Lendal Bridge Hotel under

new publican John Banton. In June and July 1888 the hotel was used to host two inquests relating to suicides in the area. A Darlington man named William Clark killed himself using a gun close to the railway station shortly after arriving in town while a few weeks later a shoemaker named Harry Empson was found drowned in the River Ouse.

By 1889 the pub was taken over by Joseph Austin Butler and was occasionally referred to as an inn rather than a hotel. Butler remained in charge until his death in February 1896 and operations were taken over by his wife Mary. By 1902 the Lendal Bridge was noted as providing customers with the option of a smoke room, a taproom and a serving bar. In 1911 it was recorded that Mary was living in the hotel with her three grandchildren, Maud, Austin and Sydney. During the outbreak of the First World War Mary was still running the Lendal Bridge Inn while her two grandsons were called up to serve in combat.

The pub was purchased from Bass Brewery in October 1992 and renamed The Maltings. An extension has recently been added to the original Victorian building.

31. THE GOLDEN BALL, Cromwell Road

The Golden Ball in Bishophill is one of York's longest running public houses and has continued to make history in the twenty-first century. In 2012 the Golden Ball became the city's first community owned cooperative pub and at the time one of only twelve nationwide. Local residents as well as investors from further afield each purchased a share to enable the lease to be bought with the pub run by the community. The project has enabled a Grade II listed pub with over 200 years of history to be potentially preserved for future generations.

A pub was first mentioned on this site in 1773 when the building next door became a school. The landlord in 1818 was Phillip Thornton while by 1828 John Penrose became licensee. Penrose remained in charge until 1849 when control passed to Eliza Penrose. In 1858 it seems the premises temporarily ceased to use the Golden Ball name and was recorded in directories as the Board, generally a term used for pubs without names. By 1861 the pub was in the control of Eliza's son John Penrose, a spirit merchant.

By 1872 William and Ann Flint were in charge with the pub referred to as the Golden Ball Inn. Flint remained in control for over a decade until Charles Clayton became landlord in 1885. Although the building was primarily erected in the early nineteenth century an extension was added in 1883 when Jail Lane was widened to become Cromwell Road. Clayton died in April 1894 aged thirty-four and his widow Mary Jane controlled the pub for a couple of years until John Gill took over.

When John Smith's Brewery of Tadcaster acquired the site in 1902 it was recorded the pub had a smoke room and vaults whilst at the bottom of a yard to the rear of the premises was a clubroom used for the playing of brass instruments. The Golden Ball underwent an extensive refurbishment in 1929, paid for by the brewery and overseen by the company's architect Bertram Wilson. The pub was renovated in the Victorian style, with both interior and exterior given a late-nineteenth-century appearance.

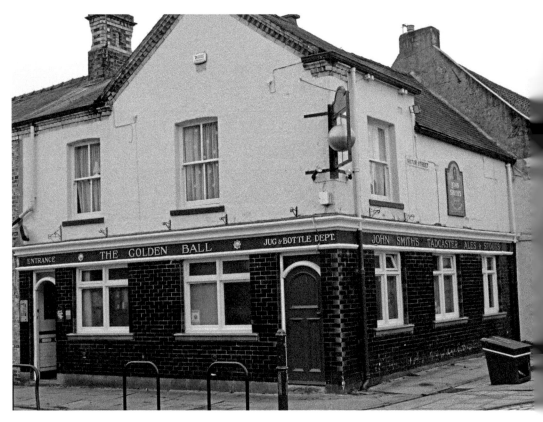

The Golden Ball.

The main entranceway was relocated from Victor Street to Cromwell Road with the ground floor exterior given a brown glazed brick façade. Permanent tiled signage was added, which amongst other things advertises John Smith's Brewery.

As a consequence the Golden Ball has one of the most complete inter war layouts of any pub in the city, remaining relatively unchanged since the refurbishment. The hall room has retained its original fixed seating and has etched windows displaying the Golden Ball Inn name. The smoke room has authentic Victorian seating along with traditional bell pushes. The main bar has a cream-tiled counter front while the John Smith's branded etched windows have also been in situ since 1929. A further feature of the Golden Ball is the unusual bar-side seated alcove.

It has been theorised that the pub may have once been frequented by Charles Dickens. The author was known to have visited York to stay with his brother Alfred and these trips may have inspired one of Dickens's most famous characters, Mr Micawber from David Copperfield. It is possible that Micawber was modelled on a resident of St Mary's Row named Richard Chicken, who by 1840 was living opposite the Golden Ball pub and was notorious for his persistent pleading of poverty. It seems possible Dickens may have once visited the pub during one of his jaunts to visit Alfred and may have met with Chicken in their local pub.

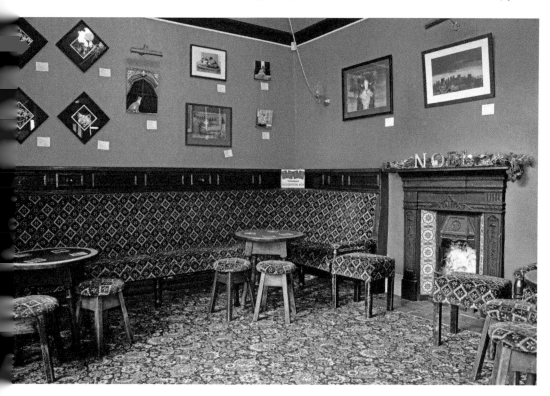

Above: The garden room, The Golden Ball.

Right: Bar-side seating alcove, The Golden Ball.

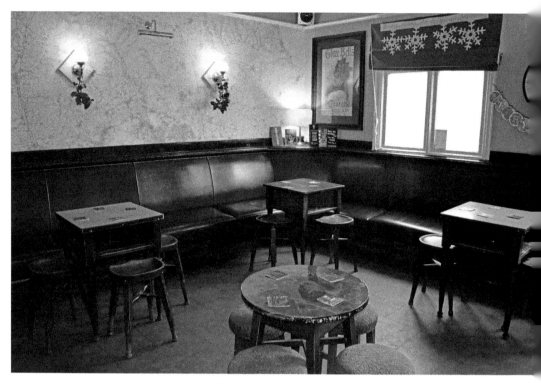

Public bar room, The Golden Ball.

32. THE SWAN, Bishopgate Street

The Swan is a relatively new public house in comparison to the plethora of pubs littered throughout the city but nonetheless possesses an interior of historic significance. During the later decades of the nineteenth century the Swan was considered to be primarily a grocer which did a side business in beer. In 1857 the house was named the Swan by owner Thomas Staverley, the name inspired by seven cygnets which had been bought by York Corporation for the River Ouse. Staverley sold the house for £400 in 1861. By 1897 the Swan was considered to be a beerhouse in the possession of Albert Addyman while in 1904 under landlord John Sumner the Swan Inn was included as a licensed house on official records. It was recorded as having a smoke room, a dram shop and a bottle and jug department for off-sales.

By 1921 the landlady was known to be Mrs A. Scaife and she remained at the Swan until 1932. By early 1935 the landlord was Frederick Avis but after his death in September that year his widow became the primary licensee. In 1936 the Swan was demolished and rebuilt by Tetley's Brewery and the interwar interior has remained relatively unchanged. Prominent features include the drinking lobby area with a terrazzo floor complete with serving hatches. The public bar's hatch is also still present while the smoke room retains its fitted bench seating and bell push rails. The Swan's intact 1930s interior is celebrated by conservationists and remains a popular community local.

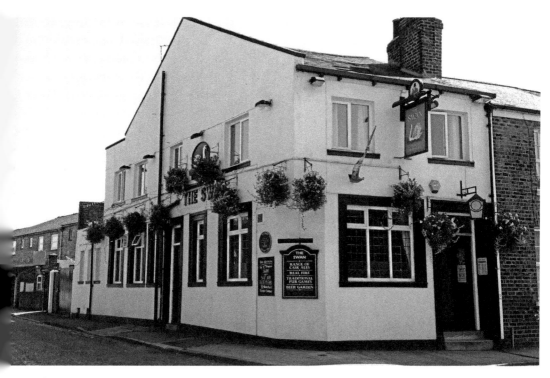

Above: The Swan.

Below: Smoke Room, The Swan.

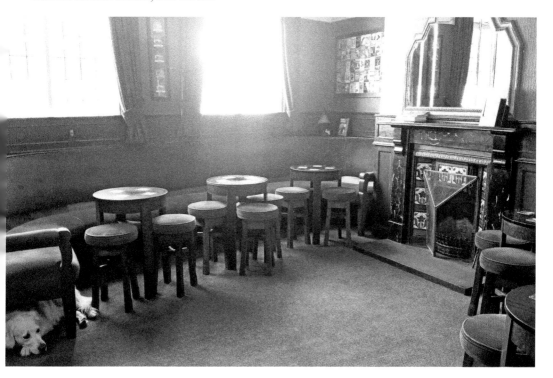

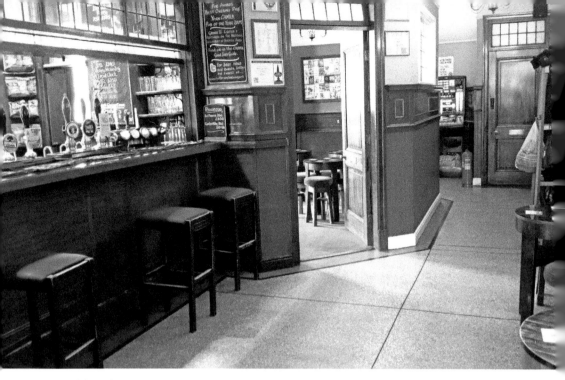

Lobby, The Swan.

Chapter Four

Walmgate and Fishergate

33. THE RED LION, Merchantgate

The Red Lion is undoubtedly one of York's most remarkable pubs, often considered an historical tourist attraction in its own right. While other pubs tussle for the title of York's oldest pub, it's probable that the Red Lion holds claim to be the pub that occupies the oldest surviving building.

The pub possesses elaborate timber framing typical of the medieval period and contains thirteenth-century foundation stones. A bread oven discovered on the site in 1976 is thought to date from the 1300s and is now displayed in the front bar. The north-east wing of the complex dates from the fifteenth century while large parts of the rest of the Red Lion have sixteenth and seventeenth century origins. A noticeable feature on the first floor is a priest hole situated between two bedrooms with access to the chimney, a convenient escape route for those under persecution. An unsubstantiated legend is that highwayman Dick Turpin once hid in the building and escaped from the upper floor, possibly via the priest hole.

The building is known to be operating as a pub by 1783 when it was trading as the Three Cups. The name is possibly related to the Company of Salters which may have been active in the area, traditionally the site of the city's fish market. Salt would have been heavily used in preserving goods on the market stalls and the pub may have been named in recognition of this, with three cups featuring on the company's coat of arms. By 1805 the name was changed to the Red Lion due to another Three Cups public house standing only forty yards away on Foss Bridge.

In 1830 the landlord was Robert Heselwood while five years later Richard Harris was advertising the Red Lion as possessing 'excellent stables and accommodation for gentlemen and farmers attending the markets'. The pig market was situated only yards from the inn's front door and the Red Lion would have been popular with farmers looking to quench their thirst. By 1838 William Fowler was the publican although in August that year he advertised that the Red Lion was available for let, boasting that the business of the inn was prosperous. Prior to 1841 widow Margaret Hudson became landlady although after her marriage to William Shepherd in 1846 her second husband

became the primary licensee. Shepherd became stepfather to his wife's children Sarah, Mary, George and Sophia as well as having a son of his own with Margaret named John. After his death in 1868 the inn passed to his stepson George Hudson.

The Shepherd-Hudson family were replaced after thirty years of tenancy by James Fletcher sometime before 1876 while a decade later Tom Ellis was publican. By 1893 Joseph Robinson was licensee with Henry Hunt Heath taking over the inn prior to the end of the century. Birmingham-born Heath was also the owner of the Crown Brewery Hotel which was situated further down Walmgate and moved into his new pub with his wife Emily and children Arthur, Alice, Walter and Hilda. In 1902 it was recorded that the Red Lion was providing two rooms for travellers with three reserved for the Heath family. On the ground floor the pub had a smoke room, a taproom and a bar.

During the nineteenth century the Red Lion was accessible only via Walmgate with the pub set back from the street and behind the Black Horse pub, which closed in 1910. Merchantgate was created in 1912 to connect Walmgate with the new Piccadilly thoroughfare to the south east of the pub and allowed greater access to the Red Lion by clearing the buildings which had stood where the roads now converge.

With low ceilings, thick Tudor beams and quaint snugs the Red Lion is a traditional English pub that is a treasure worth discovering. Whilst the pub has the nation's most common pub name it is fair to summarise that Merchantgate's Red Lion is anything but common.

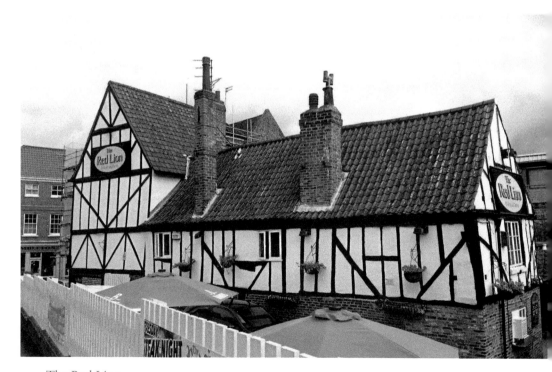

The Red Lion.

Above: Medieval wooden beams, The Red Lion.

Below: Fireplace, The Red Lion.

34. THE WATERGATE INN, Walmgate

The Watergate Inn is better known by its former name the Five Lions, a title it held for almost 200 years until a rebranding in 2015. A pub was first mentioned on the site in 1702 as the City Arms and would have been one of many establishments serving the buoyant Walmgate area. In November 1805 it was recorded that the City Arms's licensee John Taylor had become a Freeman of the Innholders Company. By 1818 the pub was renamed the Five Lions, a name which like its predecessor had connections to the city's coat of arms on which are featured five lions.

The Five Lions name would be retained for 197 years and a pub sign which once adorned the front of the building carried the inscription '*Vino bono non opus est hedera*', a Latin proverb which translated as 'good wines need no bush'. The ivy bush was historically a method of advertising that a building served ales and wines and the inference was that the Five Lions required little promotion such was the quality of their product.

In 1830 the landlord of the Five Lions was John Dunning, who remained in charge for almost a decade. By 1843 George Penty was the licensee with John Foster in place by 1849, inhabiting the pub with his wife Milcha and four children. Although Foster became a widower in 1855 he retained control of the Five Lions until 1866 when he was forced to relinquish the pub due to ill health. Owners Roper & Melrose Brewery took out an advert seeking a new tenant and within a year Henry Schofield was running the premises. During Schofield's tenure the pub continued to thrive as a traditional coaching inn and in 1881 was still hosting carriers which left for Full Sutton and Weldrake every Saturday.

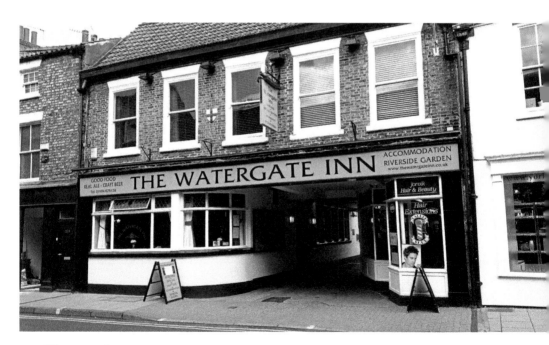

Watergate Inn.

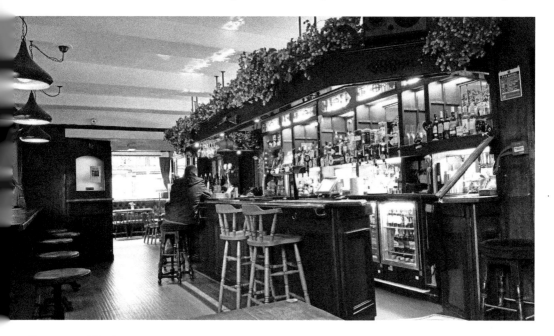

Bar room, The Watergate Inn.

By 1886 James Henry Murphy was landlord followed by John Thomas Brown three years later. In 1896 a farmer named Francis Wilson was kicked in the head by a horse in the Five Lion's stables and later died of his injuries. Shortly afterward William Frederick Thompson became landlord and moved into the pub with his wife Mary and daughter Maud. During Thompson's decade running the pub the Five Lions was noted as containing nine bedrooms and offered good quality accommodation to travellers. The pub consisted of standard features like a smoke room and bar room and also utilised a large dining room for ladies. During this period the pub also advertised accommodation specifically for cyclists, attempting to take advantage of the new mode of transport.

Since the turn of the twentieth century the pub has undergone a significant degree of renovation and is unrecognisable inside. While the façade has also been altered the conspicuous entranceway into the yard is still extant with the old stables now converted into accommodation.

35. THE PHOENIX, George Street

The Phoenix is situated in close proximity to Fishergate Bar and is the last surviving pub within the city walls which once served the old cattle market. A pub probably operated on this site in the late eighteenth century and it would have benefited from the busy trade which took place at the nearby market. Fishergate Bar was ravaged with fire in 1489 during a rebellion against King Henry VII and was bricked up by the authorities. This brick barrier was only removed in 1834 and would have further increased access to the area and thus the pub.

The pub was called the Labour in Vain during the early nineteenth century and in 1839 was run by Ann Jolly. Ann's deceased vessel-owner husband John Jolly had previously owned a pub on King's Staith also called the Labour in Vain and it seems likely Ann retained the name when she moved to George Street. The name and associated imagery is considered controversial in the present era but during the early Victorian era was prevalent across the country. Although the name seems innocuous it was often accompanied with a pub sign which depicted a woman scrubbing a black child with the slogan 'you may wash him and scrub him from morning to night, your labour's in vain, black will never come white'.

Ann Jolly retained control for over fifteen years until her death in 1854 aged sixty-seven. She was buried in the nearby St George's Courtyard. By 1858 the new landlady was Caroline Pemberton along with her son John and daughter Jane. The pub had acquired the informal name of the Black Boy by this period, alluding to the pub sign. In 1867 the pub was renamed the Phoenix with William Sawyer the new publican. It has been theorised that the new name was adapted from the nearby Phoenix Iron Foundry. Over the next three decades the pub underwent a succession of short-term landlords, including Joseph Smith in 1872, Benjamin Stephenson in 1876, James Renwick in 1881 and William Blakely in 1889. By 1893 Thomas Page had taken over before John Atherley became licensee in 1896.

As well as John the Atherley family comprised of his wife Annie and adult children Beatrice and Ernest who worked in the pub, which in 1902 consisted of two smoke rooms and a serving bar. Although later renovations have taken place the pub still retains its basic internal outlay. The bar room contains a large etched glass window bearing the pub's name with a serving hatch in the lobby providing access to the bar.

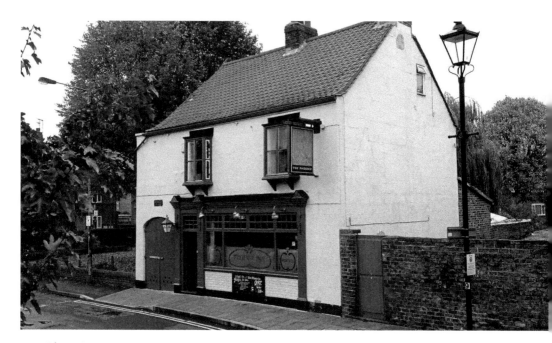

Phoenix.

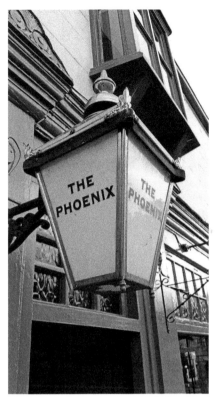

Exterior lamp, The Phoenix.

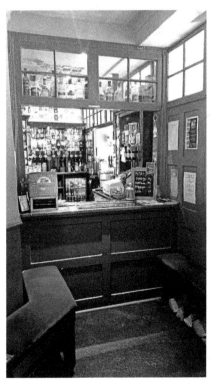

Serving hatch, The Phoenix.

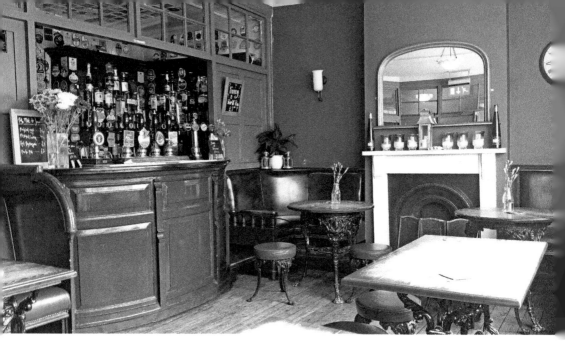

Bar room, The Phoenix.

36. MASONS ARMS, Fishergate

The current Masons Arms was rebuilt in the 1930s but had traded on the site for over a century before its remodelling. A pub was first mentioned in 1835 when a stonemason named George Tilney applied for a licence to sell alcohol. The pub's name was given as the Quiet Woman and was notable for a sign which featured the gruesome image of a decapitated woman carrying her head. Tilney was initially rejected by the city authorities but three years later was successful in his attempt to attain a licence and took over the Quiet Woman. Tilney changed the name of the pub to the Masons Arms, reflecting his past trade, a name it has retained ever since.

By 1843 David Cobb was landlord of the Masons Arms until Richard Powell took over in 1851. By 1858 William Skilbeck was the licensee while three years later George Anderson was in charge. In 1867 William Storry moved into the pub and remained as landlord for over twelve years. In August 1868 it was reported that a local woman named Jane Keech had left the Masons Arms one night around midnight after drinking brandy and water. The following morning her body was found floating in the nearby River Foss. Ten years later Storry's pub was listed for sale and was particularly noted for its 'excellent, well-arranged and most complete brewhouse'. Other assets the pub contained included 'an imposing dram shop, with plate glass window' along with two entrances, a taproom and a large parlour bar. The property overall was considered to be in excellent repair and promised a 'large and lucrative trade'.

By 1881 John Doughty became licensee and lived at the pub with his wife Elizabeth and young daughters Florence and Beatrice. Doughty stayed at the Masons Arms until his death in 1887 aged thirty-eight. By 1889 Frederick Stroud was the licensee followed by Edgar Lee in 1893 and Henry Pratt in 1895. Pratt was an experienced licensee originally from Ely in Cambridgeshire and remained at the Masons until around 1903

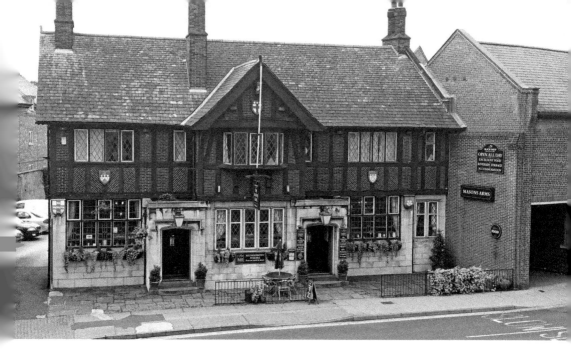

Above: Masons Arms.

Right: Fireplace from York Castle, Masons Arms.

when he moved to the Sea Horses Hotel in nearby Fawcett Street. Under Pratt's tenure the pub was known to be offering a single room to travellers and contained a smoke room, a bar and a taproom.

In 1935 the pub was completely rebuilt in the mock-Tudor style that was popular with breweries of the period and was set back from the street. Notable features inside include substantial oak panelling and a well-preserved fireplace which were salvaged from the demolished prison and incorporated into the new pub.

37. ROOK AND GASKILL, Lawrence Street

The Rook and Gaskill has been trading just outside Walmgate Bar for 200 years and has undergone a number of name changes during that period. In 1818 the pub was trading as the Wheatsheaf with the landlord recorded as John Hillary. The address at this time was given as Walmgate Bar Without and indicates the pub's proximity to the medieval structure. By 1829 William Hutton was licensee followed by John Kendall a year later. In 1834 the Wheatsheaf name was cast aside and the pub briefly became known as the Princess Victoria.

After Victoria's accession to the British throne three years later the pub accordingly altered its name to the Queen Victoria, by which it was known to be trading as in 1843 under landlord William Haxby. By 1846 Joseph Coupland was licensee and retained control until 1851 at least, when the pub was generally known as the Victoria. After a short period called the Queen's Head in 1857 the name was simplified to the Queen Inn a year later under new publican John McMenamy, a name it would retain over the next 140 years.

McMenamy, who was originally from Dungannon in Northern Ireland, remained in place at the Queen until his death when he was replaced by his wife Mary, who was still running the pub in 1880. By 1881 another Irishman Martin Crane was licensee and begun a three-decade family connection with the Queen Inn. A family spat made local press in March 1894 when it was reported that Martin's son Walter was charged with being drunk on the premises of the Queen and assaulting his mother Bridget. He was fined 10s for the drunkenness and sentenced to a month's hard labour for his assault. After Martin's death toward the end of the century his daughter, also named Bridget, became the primary licensee and continued to run the pub for the next two decades, including through the First World War.

By 1902 the Queen was known to possess seven bedrooms with four reserved for the use of travellers, the other three for the Crane family, which included Bridget and her mother. On the ground floor was a smoke room, a taproom, a dining room and a spirit store. The Crane family relinquished control of the Queen in 1923 after the death of the younger Bridget Crane, aged sixty-one.

In 1934 the Queen was being run by a locally-prominent Welsh rugby player named William Davies, who at the time was playing for Castleford. He was taken to court in May that year charged with supplying intoxicating liquor to a group of men to be consumed off the premises. The case collapsed with a defence explaining the beer and stout had been paid for earlier in the day during licensing hours, which the judge accepted. Davies went on to play for Castleford at Wembley a year later, winning the Challenge Cup.

In 2002 the pub was purchased by York Brewery who renamed the pub the Rook and Gaskill in keeping with their theme of giving their establishments names connected with historic capital punishment. Rook and Gaskill refers to the last two men to be hanged at St Leonard's gallows at Greendykes. Peter Rook and Leonard Gaskill of Beverley were executed on 12 May 1676 for stealing thirteen sheep from John Brown of Driffield.

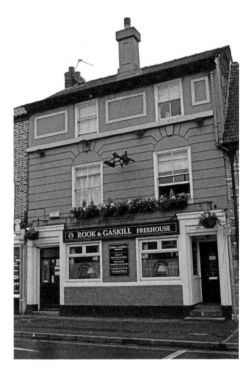

Right: Rook and Gaskill.

Below: Interior, Rook and Gaskill.

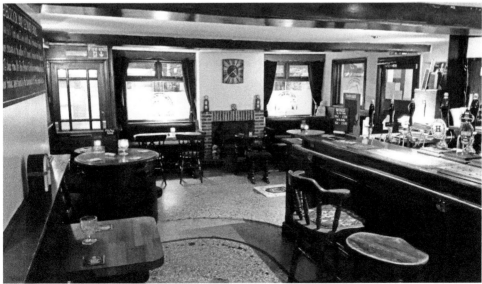

38. ROSE AND CROWN, Lawrence Street

The Rose and Crown can claim to be one of York's longest continuously licensed pubs and traces its origins as a public house to 1786, a fact highlighted on the present signage.

The building was initially erected in the early eighteenth century as two separate houses before amalgamating into the one premises it currently occupies. In 1818 the address was given as Walmgate Bar Without and the landlord was William Clarke. By 1829 William Armitage was in charge followed a year later by Sarah Mickle. By 1838 John Ramsdale was the licensee, occupying the pub with his wife Harriet and son Robert. Ramsdale remained in charge until his death in April 1852 when he was seventy-five years old and was replaced by William Sturdy.

Sturdy was originally from Market Weighton and moved into the pub with his wife Mary, who died in 1859 aged fifty-five. William remained in charge for over two decades until his death in 1879 and was replaced by his second wife, Isabella Sturdy. By 1886 Thomas Agnew was the publican until 1889 when George Dalton took over, with Agnew moving to the nearby Waggon and Horses. Dalton himself would make the same move in 1900. Dalton was replaced by Cornelius Burton for a couple of years who moved into the pub with his wife and their six children, all aged under eight years old.

Peter Dunn took over in 1902 and his pub was known to possess two smoke rooms, a taproom and a club room. The inn only offered two of its five bedrooms to travellers. The decorative patterned tiling prominent throughout the pub is the result of a 1928 refurbishment by Tetley Brewery. The Rose and Crown has remained trading for over 230 years in an advantageous position on the busy York to Hull thoroughfare and close to the city's various livestock markets. Although no longer principally trading to travellers it is nonetheless still a busy public house.

Rose and Crown.

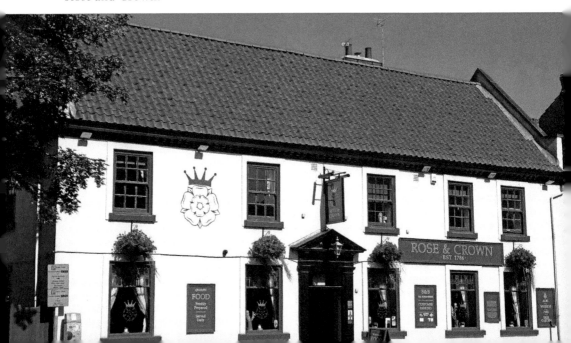

Right: Coloured tiling, Rose and Crown.

Below: Front bar room, Rose and Crown.

39. WAGGON AND HORSES, Lawrence Street

A pub first begun trading on this site in the late eighteenth century and by 1791 was known as the Waggon. Four years later it became the Waggon and Horses, a name it has retained until the present day.

In 1818 the address was listed as Walmgate Bar and the licensee was Robert Fisher. Fisher remained in charge of the Waggon until 1851, a tenure of over thirty years. He was replaced that year by his son, also named Robert. The younger Fisher spent almost seventeen years in charge of the Waggon, until he was replaced in 1876 by Charles Hardcastle. The Fisher family had spent almost sixty years running the Waggon and Horses and at one point in 1851 three generations of the Fisher family lived within the pub walls; the patriarch Robert Fisher, his son and daughter-in-law Robert and Ann, and his grandchildren William, Frances and Dinah.

Charles Hardcastle, a farmer by trade who owned forty-two acres of land, was replaced in 1886 by another farmer named William Burland. In 1889 Thomas Agnew transferred from the Rose and Crown a few doors away, followed by Alexander McCraith in 1893. In June 1895 McCraith's wife Margaret Ellen died at the inn aged only twenty-four.

In 1900 George Dalton, formerly of the Rose and Crown, moved into the Waggon and remained in place for over a decade. During Dalton's tenure as landlord the Waggon and Horses was still a substantial coaching inn and was capable of housing up to twenty travellers at any one time in their ten bedrooms. The pub at this time consisted of two smoke rooms and a dram shop and was still a popular venue.

By 1911 William Moses Marshall was in charge of the pub and retained control throughout the First World War. The Marshalls were a large family and consisted of William's wife Eleanor, adult children Gertrude, Harry, Martha and Mildred along with two minors named Frank and Hattie. The Marshalls remained at the Waggon and Horses until the 1930s. The lounge and bar rooms still retain excellent examples of etched glass windows.

Waggon and Horses.

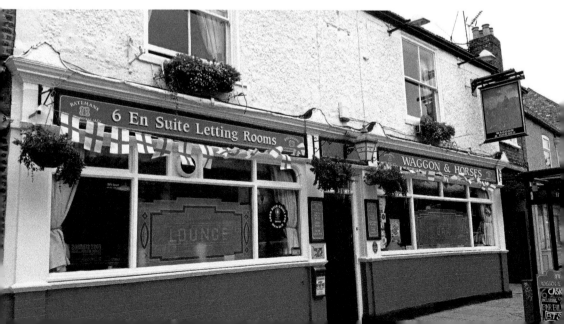

Acknowledgements

This book could not have been completed without the hard work and research undertaken by previous authors of books on York's pubs. The books in particular which have been of great help to me can be found in the bibliography and all come recommended. I must thank Explore York, the city's library service, for the use of their facilities over the last year without which the book wouldn't have been completed.

I am thankful for the assistance that Keith Martin of York CAMRA gave to me at the outset of the book, including generously sharing his own research with me. I am indebted to his continued help. I must also pay tribute to the pubs and landlords featured in this book for their hard work in running their establishments for the enjoyment of people such as myself. Many of them proved to be hospitable venues during research and accommodating regarding photographs. Also helpful were my editors Christian Duck and Jenny Stephens at Amberley Publishing who have seen the book through to completion as well as the team at large.

Lastly I must acknowledge the support and backing of my family in completing this book; thanks to my mother Michelle, father Mohammed and two sisters Nadia and Yasmin. I also thank my grandparents Muriel and Randall for their ever-present encouragement. Finally my wife Katherine, who is responsible for me being in York in the first place, I pay tribute for your good nature during my many hours spent in the pub!

Bibliography

Bruning, T., *Historic Inns of England*, London: Prion Books 2000.

Cooper, T. P., *The Old Inns and Inn Signs of York*, York: Delittle & Sons 1897.

Coxon, P., *Landlords & Rogues in & Around York's Old Inn*, Barnsley: Wharncliffe Books 2006.

Coxon, P., *York's Historic Inns*, York: The Evening Press 1998.

Hayden, P., *The English Pub: A History*, London: Robert Hole Ltd 1994.

Jennings, P., *The Local; A History of the English Pub*, Stroud: History Press 2007.

Johnson, A., *The Inns and Alehouses of York*, Beverley: Hutton Press 1989.

Lister, P., *Ghosts & Gravestones of York*, Stroud: Tempus Publishing 2007.

Monckton, H. A., *A History of the English Public House*, London: Bodley Head 1969.

Moore, J & Nero, P., *Ye Olde Good Inn Guide*, Stroud: History Press 2013.

Murray, H., *A Directory of York Pubs 1455–2003*, York: Voyager Publications 2003.

Race, M., *Public Houses, Private Lives; An Oral History of Life in York Pubs in the Mid-20th Century*, York: Voyager Publications 1999.

Rowntree, B. S., *Poverty; A Study of Town Life*, London: Macmillan and Co 1901.

Shaw, D., *Ghost Walks Around York*, Ammanford: Sigma Press 2012.

White, E., *Feeding a City: York*, Trowbridge: Prospect Books 2000.

Ancestry.co.uk
BritishNewspaperArchive.co.uk
ExploreYork.co.uk
YorkCamra.org.uk

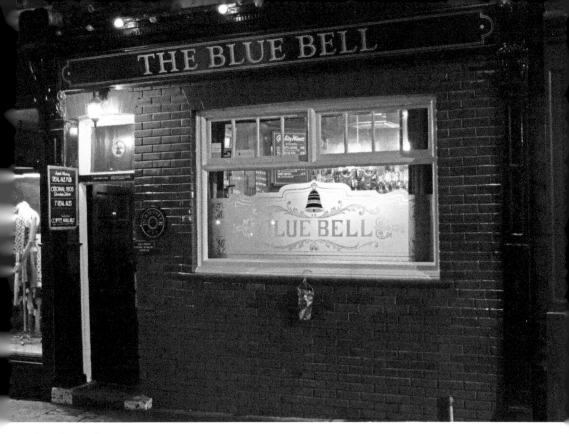

The Blue Bell.

Also Available from Amberley Publishing

PAUL CHRYSTAL & SIMON CROSSLEY

VALE OF YORK

THROUGH TIME

This fascinating selection of photographs traces some of the many ways in which the Vale of York has changed and developed over the last century.

Paperback
180 illustrations
96 pages
978-1-4456-4470-7

Available from all good bookshops or to order direct
please call **01453-847-800**
www.amberley-books.com